Professional
Interior
Photography

To Leo George with love

Professional Interior Photography

Third Edition

Michael Harris

Focal Press

OXFORD AMSTERDAM BOSTON LONDON NEW YORK PARIS
SAN DIEGO SAN FRANCISCO SINGAPORE SYDNEY TOKYO

Focal Press
An imprint of Elsevier Science
Linacre House, Jordan Hill, Oxford OX2 8DP
200 Wheeler Road, Burlington MA 01803

First published as *The Manual of Interior Photography* 1993
Reprinted 1995
Second edition 1998
Third edition 2003

British Library Cataloguing in Publication Data
A catalogue record for this book is available from the British Library

Library of Congress Cataloguing in Publication Data
A catalogue record for this book is available from the Library of Congress

ISBN 0 240 51902 7

For information on all Focal Press publications
visit our website at www.focalpress.com

Composition by Genesis Typesetting, Rochester, Kent
Printed and bound in Italy

CONTENTS

PROFESSIONAL
INTERIOR
PHOTOGRAPHY

■

PREFACE

With the publication of every new edition of this book we have taken another few steps in the shift from silver halide photography to modern digital imaging. Indeed, the first edition in 1993 failed to even mention the advent of 'electronic imaging' as it was then known.

But now plenty of photographers, including those featured in this book, are making use of digital technology in one way or another. In the last edition, I said we were 'standing on the brink of the digital imaging revolution'. That revolution is now establishing itself at an ever-accelerating pace, going beyond digital press work and high-end studio systems, to commercial location work, including interiors. Even film giant Fuji ran a recent advertising campaign with the slogan: 'Film. It's a creative choice', thereby acknowledging the real choice there is to be made between the two mediums.

Chapter 3 takes a close look at the advantages and disadvantages for interior photographers in the 'film versus digital' debate, and features Ashley Morrison, an interior photographer who works almost exclusively with digital cameras and can scarcely find enough words to praise the positive aspects of this new technology.

This book is written as a companion volume to *Professional Architectural Photography*, which concentrates on the photography of the structure of buildings, especially their exteriors.

Michael G. Harris

ACKNOWLEDGEMENTS

I extend my very special thanks to all the photographers, past and present, whose work features in this book. We all share a similar passion that transcends time, enabling us to appreciate equally the work of interior photographers working 100 years ago with those at the top of their profession today.

I am particularly indebted to Ashley Morrison who shares with us the details of his digital working practices in Chapter 3, along with Derek Kendall, Brian Harrison, Andreas von Einsiedel and Peter Aprahamian who give us an invaluable practical insight into their lives and working methods in the Appendix at the end of this book.

My thanks also go to my commissioning editors Christina Donaldson and Marie Hooper for their assistance, enthusiasm and encouragement, and to Peter Grainger and his colleagues at Photocare Laboratories in Tonbridge for their efficient, high quality processing and printing services.

Last, but by no means least, I thank Val, my wife, and my children Leo and Billy for their support in this project

All the photographs in this book were taken by the author unless otherwise specified.

PROFESSIONAL
INTERIOR
PHOTOGRAPHY
■

ix

THE ARTISTIC INTERPRETATION OF INTERIORS

We seem to have a natural fascination with the way people choose to decorate and furnish their homes, as is borne out by the multitude of interior magazines that grace the shelves of every newsagent. This is in part nosiness – to catch a glimpse of a private sanctuary that usually remains behind closed doors – and in part an aesthetic appreciation of interior design, from which personal styles can be developed or copied. The extent to which this is successful depends on the confidence of the designer and stylist to create aesthetically appealing interiors, and the ability of the artist or photographer to express these three-dimensional atmospheric experiences as mere two-dimensional images. This chapter begins with a look at how artists and photographers have chosen to depict interiors, and concludes with a brief history of interior decoration as useful background knowledge.

Seventeenth-century interpretation

The artistic interpretation of interiors has a long historical tradition, perhaps best exemplified by the Dutch masters of the seventeenth century. The exaggerated realism of the contrast of light and shade in their paintings stimulates in the viewer a sense of magic, romance and nostalgia.

The oil painting by Pieter de Hooch in Figure 1.1, *An Interior, with a Woman Drinking with Two Men* (1658), is a fine example, and his work is described by art historian Mariet Westermann in *The Art of the Dutch Republic 1585–1718* (1996) in the following way:

> De Hooch, and the majority of painters represented in this book share one of the uncanniest realist strategies: a fine meticulous handling of oil paint that makes the

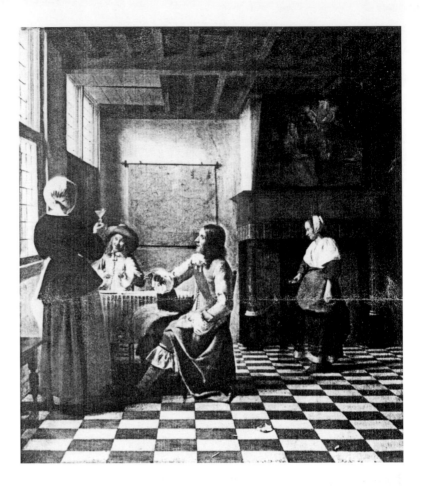

Figure 1.1 *An Interior, with a Woman Drinking with Two Men* (1658), Pieter de Hooch (courtesy of the National Gallery)

individual strokes of paint difficult or impossible to discern. This smooth technique, combined with a keen regard for the reflections and refractions of light and the appearance of different colours and textures under various illuminations, creates the widely acknowledged photographic quality of Dutch paintings. Indeed ... these paintings can seem to outdo the most sensitive of photographs in capturing textures revealed by light. This look of truth depends on the viewer's perception that no one had a hand in the representation: the meticulous, smooth technique erases all evidence of handiwork. The effect is paradoxical, as the artist's ostensible self-effacement in technique almost immediately calls attention to its very brilliance.

This passage perfectly mirrors the art and techniques of interior photography: a 'realist strategy'; 'a keen regard for the reflections and refractions of light'; and, most importantly,

that 'this look of truth depends on the viewer's perception that no one had a hand in the representation'.

Interior photography strives to achieve the same goal, but with different tools and different materials. This 'look of truth' is rarely achieved with natural light alone, because of the limited tonal range of photographic film. The contrast between the light and shade areas in an interior, though readily discernible to the eye, is usually too great to record on film: the light areas tend to 'burn out', and the shadow areas become a black void. In order to reduce the contrast to enable us to record the image clearly on film, we have to supplement the existing ambient light with photographic 'fill-in' lighting. This has to be done very subtly to preserve the atmosphere and interplay of light and shade in the room, while reducing the contrast to acceptable photographic levels. It is this subtlety that is the photographer's 'ostensible self-effacement in technique [that] almost immediately calls attention to its very brilliance'.

This brilliance of deception is the mark of a successful interior photograph. The challenge of balancing the variables of composition, styling and lighting to create this 'look of truth' is the thrill that stimulates interior photographers in their day-to-day work.

Photographic interpretation from the nineteenth century

With the advent of photography in the mid-nineteenth century came the emergence of the first firms specializing in the photographic recording of contemporary architecture, both inside and out. The best known in England was Bedford Lemere & Co., who set the standards for others to follow – see Figure 1.5. The firm used gelatin dry-plates, introduced commercially in the 1870s, which freed the location photographer from the portable darkroom needed for the wet collodion process, and enabled development to be undertaken long after exposure. These dry plates were also more sensitive to light, allowing much shorter development times. Harry Bedford Lemere worked with a Meagher 12 in × 10 in mahogany bellows camera using small apertures and long exposures for sharp definition throughout his images.

There was an explosion of new magazines with the introduction of half-tone printing in the 1890s whereby for the first time it was possible to print photographs and type together in a single operation. The most influential of these

Figure 1.2 Clouds, Wiltshire (1904), by *Country Life* photographer Charles Latham (courtesy of the British Architectural Library Photographs Collection)

was *Country Life* and it was photographer Charles Latham (Figure 1.2) whose imaginative and perfectly executed interior shots created the magazine's tradition of fine country house photography. Through its wide readership, this in turn influenced fashions in interior design, much as interior magazines do to this day. Frederick Evans also supplied *Country Life* with interior shots, though of a more pictorial and romantic nature. He was famous for his cathedral interiors, believing that his true aim as a photographer was to record emotion: to convey the sensations, both spiritual and aesthetic, that medieval architecture aroused in him. He abandoned all-inclusive compositions for a more fragmentary approach, preferring to use the longest focal-length lens possible to create views through different parts of the buildings, meticulously recording the subtle gradations of light and shade within these medieval interiors. This approach is still seen in modern interior magazine photography to this day.

The artistic revolution of the 1920s and 1930s was a time of radical experimentation and utopian optimism in architecture, embracing new technology with the birth of functional modernism. The clean lines and forms of modern architecture suited a more abstract photographic style, encouraging dramatic lighting and camera angles, exemplified by the work of the Dell and Wainwright Partnership who were official photographers to *Architectural Review* from 1930 to 1946. They favoured bird's and worm's eye views for both interiors and exteriors, and oblique angle shots to show repetitive rhythms in the architecture. High contrast, stark lighting (often from a low angle) and deep shadows became the hallmark of these new interior photographs, as seen in the work of Sydney Newbery (see Figure 1.6) who became official photographer for the *Architects' Journal* in 1920. In fact, architects faced criticism for imitating the photographer: building with lights and shadows in black and white, thereby underlining the reciprocal relationship that existed between photography and architecture at this time.

The widespread use of colour photography since the 1970s, combined with the ubiquitous growth of interior magazines, company brochures, property brochures and illustrated annual reports, have presented photographers and designers with ever more creative opportunities. A postmodern array of styles and techniques can be employed, especially with the design and photo-manipulation techniques available since the 1990s through digital imaging.

A brief history of interior decoration

Before the days of electric or gas lighting, architects designed interiors specifically around available window light, and this is still the case for most residential interiors. For modern commercial buildings, architects are more likely to design around a combination of natural and artificial lighting, but with equal intensity of consideration being given to the overall aesthetic concept. It is the work of the interior photographer to capture on film the essence of this concept, through recording the interplay of available light and shade (whatever the source) with the proportions and furnishings of the room.

There are, of course, many different ways of arranging and decorating a house. Both practical necessity and the prevailing fashions at different periods through history have influenced the common way of arranging rooms. For example, in Norman times, the discomfort caused by fires laid on the floor in the centre of the great hall led to the introduction of the fireplace, then as now the focal point of the room. Similarly, the small, wooden-shuttered windows of Norman castles were practically designed as both a defensive measure and for protection from the weather. It was not until the sixteenth century that both the size and number of windows increased as glass factories developed and houses no longer had to be built with defence in mind.

Medieval and Tudor interiors

The inside walls of medieval houses were either plastered for insulation and painted with decorative patterns, or had wainscoting made from narrow vertical boards joined together and painted. In the fourteenth century tapestries were introduced as wall-hangings, and carpets started to appear in the richest households, initially as table coverings. Furniture was scarce: some chests and coffers, benches and dining tables (boards on trestles), and the most treasured piece of furniture in the house, the bed.

The open medieval hall became partitioned with a wooden screen at one end to cut out draughts from the doors. The gallery followed soon after as a platform for musical performance. Both lent themselves to elaborate decoration in the form of carving.

By the sixteenth century ceilings were constructed in houses to add an extra floor of accommodation, and they provided an extra surface to decorate with ingenious patterns in plaster. Richly carved wide staircases would lead upstairs

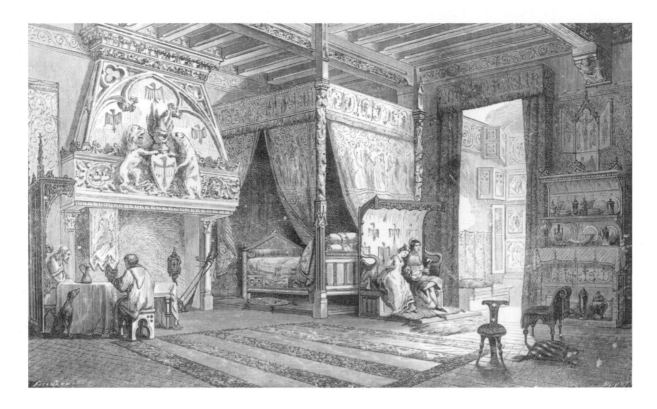

to the bedrooms, library, chapel and long gallery – a room that ran the length of the house where people could walk for exercise on wet days, children could play, and concerts could be held. It was also around this time that wallpaper was introduced, providing a cheap substitute for expensive wall hangings.

While we have concentrated so far on the grand houses built by rich landowners, the ordinary folk were also improving their houses. Wooden-shuttered windows of oiled linen or paper were replaced with bigger windows made of diamond-shaped panes of glass. Fireplaces with brick chimneys made it safer to add an upper room over the parlour, and ladders were replaced by staircases. A farmer would add a brick fireplace at one end of his parlour, with seats on either side and the fire in the middle: the 'inglenook'.

The seventeenth century

James I became King of England in 1603. He actively encouraged closer links with the Continent thereby fostering the first real understanding of design in architecture and decoration, based on the classical rules of order and proportion. Until Stuart times, major buildings were the product of the combined achievements of patrons and their

Figure 1.3 A fifteenth-century interior, showing the bed as the dominant feature

master masons, while houses were built by craftsmen according to local tradition, using locally available materials. A well-educated client would often direct the building of his own house, having a broader outlook through travel and books than the local builder. It was Inigo Jones, as Surveyor of the King's Works, who transformed English architecture, following extensive travels in Italy. Jones's inspiration was the work of Italian architect Andrea Palladio, who had revived the Roman classical style of symmetrical planning and harmonious proportion as part of Italy's Renaissance. Stone and brick were often used instead of timber, and the regular positioning of vertical and rectangular windows gave a more even distribution of light which affected the arrangement of furniture in rooms and led to the development of curtaining around windows. Doors and fireplaces were as carefully positioned as windows following the firm principles of classical building. Architects began to plan houses in a more compact and sensible way: rooms were no longer strung out in draughty wings, but were arranged on either side of a central corridor.

The eighteenth century

It was during the eighteenth century that the role of the professional architect was established as leader of a team of craftsmen. He would produce proposals for the building, both inside and out, to which the client could react and a compromise would be reached. Working in the Renaissance tradition, architects had to involve themselves with interior structure and decoration in order to create a unified, harmonious scheme. However, the architect was primarily responsible for structural work, so when just a change of interior decoration was required in a house, an upholsterer would be called in. The upholsterer would offer both an upholstery service and a complete decorating service, coordinating the work of many subcontractors.

The palatial baroque style reached England from the Continent in the 1670s. It was characterized by a desire to impress with scale, drama and visible extravagance. The 'enfilade' is a good example of this, whereby the doors from each room to the next are aligned to give an imposing vista from one end of the house to the other. Illusionist paintings and the 'trompe l'oeil' effect were also popular.

The early eighteenth century saw a Palladian revival and a belief in the correctness of classical architecture. Great

wealth gained from increased trade led to the building of vast country and town houses with pillared fronts. Such Georgian houses had plain yet imposing exteriors and magnificent interiors. There was always a grand entrance hall for receiving guests, along with drawing-, dining- and card-rooms, a library, bedrooms, etc., not to mention the kitchen, pantries, cellars and servants' quarters. The Grand Tour became part of a young gentleman's education, from which he would acquire a mass of pictures, objects and sculpture with which to decorate his home.

By the middle of the century, the rococo style was imported from France as a reaction against the 'architectural' decoration of neo-Palladianism. By contrast, it was light-hearted and lavish in ornamentation: asymmetrical designs with scrolls and flowing sinuous lines. Natural forms – plants and flowers – were used in the designs for textiles and wallpapers.

Figure 1.4 A typical Adam interior, Portland Place, London

A further classical revival followed, initiated this time by Robert Adam after his Grand Tour at a time of extensive excavations in Italy and Greece. Neoclassical architects such as Adam were the first to design complete schemes for interiors: from walls and ceilings, through furniture and upholstery, to carpets, fireplaces, door furniture and light-fittings, the latter often in the form of elaborate chandeliers. Most of his work involved the redecoration of existing houses using curved walls, alcoves and pillars covered in fine plaster, and painted in delicate colours with gilt decoration. He used a variety of classical motifs, often enclosed in round, oval or rectangular shapes.

The nineteenth century

By the end of the eighteenth century, the classical disciplines were being swept away by the revolutionary Romantic movement of the Regency period. The formal approach to living was rejected in favour of informality. The former library became the living-room, the drawing-room was reserved only for formal receptions, and the concepts of the conservatory and breakfast-room were introduced. Convenience and comfort replaced ceremony. Sofas and chairs, traditionally placed against walls throughout the previous history of interior arrangements, were now positioned at right angles to, or facing, the fireplace where they have remained to this day. The sofa table was introduced and drapery was used in excess, especially for the highly swagged floor-length curtains popular at the time.

By the 1820s there was a growing fashion for eclectic Gothic decoration, inspired by its association with Englishness and godliness. Indiscriminate use was made of styles from Norman to Elizabethan, using rich glowing colours with plenty of gold, stained glass, heraldry and Gothic arched windows. This led to what became known as the 'Battle of the Styles' between the classicists and the 'Goths', both having complete disregard for historical accuracy. This was, in part at least, a result of the new type of patronage based on wealth rather than education. The Gothic style proved the more popular, and this is the legacy we tend to associate with Victorian architecture today.

Mass production by the mid-nineteenth century gave birth to new stores: Maples and Heal's, for example, where customers were able to buy a whole range of ready-made goods. Interior decoration became muddled and cluttered,

exaggerated by the plethora of knick-knacks and collected objects used to express individuality in a world of mass production. An inevitable backlash to this was the 'Arts and Crafts' movement, inspired by William Morris, which evolved to revive handicrafts and reform architecture by using traditional building crafts and local materials.

Influenced by Morris, another reactionary was designer and architect Charles Annesley Voysey who also became a leading member of the 'Arts and Crafts' movement. He built a large number of unpretentious country houses, neither very large nor grand, and placed them in intimate relationship with nature. The exteriors were usually rendered with pebbledash and had long horizontal windows. The rooms had lowish ceilings and white walls, creating a very modern appearance.

Figure 1.5 Leighton House, London (1895), by Bedford Lemere & Co., one of the first firms to specialize in the photographic recording of contemporary architecture, both inside and out (courtesy of the British Architectural Library Photographs Collection)

PROFESSIONAL
INTERIOR
PHOTOGRAPHY
■

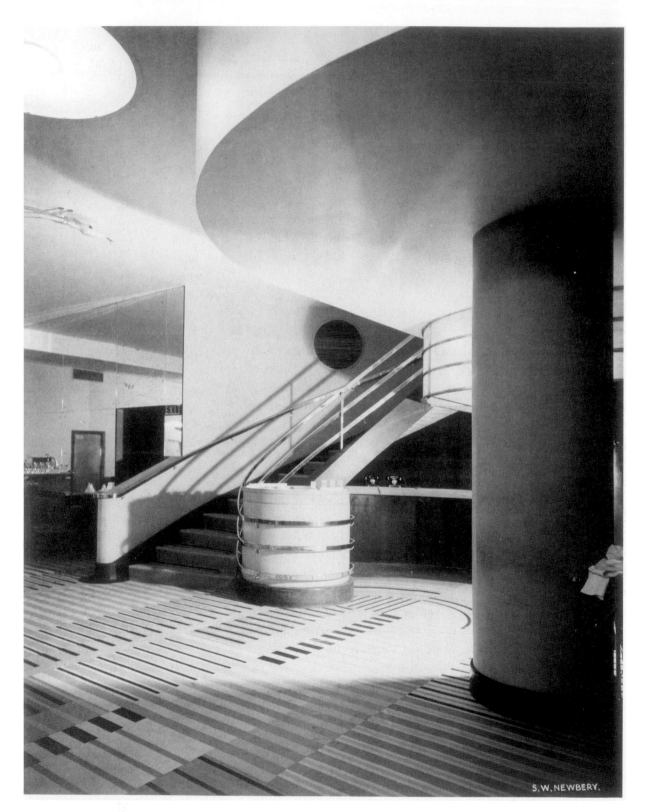

Figure 1.6 Fischer's Restaurant, London (1933), by Sydney Newbery, official photographer for *Architects' Journal* (courtesy of the British Architectural Library Photographs Collection)

Also born out of the 'Arts and Crafts' movement came Art Nouveau with its infusion of Japonaiserie, the asymmetrical undulations of rococo and, later, the influence of Celtic art. Its climax in Britain was the work of Charles Rennie Mackintosh in whose architecture and decoration the subtle colours of Art Nouveau blended with the modern, clean white interior.

The twentieth century

Of great importance just before the turn of the century were, of course, the inventions of the light bulb, the incandescent mantle for gaslight and the gas fire. Central heating for the wealthy followed soon after, though its progress was slow. By 1919 only six per cent of houses had electricity.

In contrast with the cluttered interiors of the late Victorian period, the 1920s and 1930s saw a preoccupation with minimal 'streamline modern', associated with speed and aerodynamics. Built-in furniture was simply painted white, with rounded corners. Swiss architect Le Corbusier described a house as 'a machine for living in', preferring concrete to brick, and sleek flat roofs. However, the modern movement or 'International Style', with its lack of decoration and ornamentation, had little appeal for the rich and fashionable who preferred to continue with Renaissance and rococo styles.

The longest lasting style of the twentieth century has been the 'country house look', established by decorators Colefax and Fowler in the late 1930s. The style is associated with what many have regarded as the ideal way of life, and has been promoted by such magazines as *Vogue*, *House and Garden* and *Country Life* ever since. While there is a growing appreciation for modern interior decoration, we still enjoy revivals and the influence of the halcyon past, as has characterized the history of interior decoration.

2 SPECIALIST HARDWARE FOR IMAGE CAPTURE

There is a huge variety of cameras, both film and digital, available on the photographic market. This can be an exciting but daunting choice, as making the wrong selection could prove to be very costly, especially at such a moment in time when we are poised between the two different photographic technologies. While the two technologies are critically compared in the next chapter, the actual *type* of camera you choose is likely to be the same for both film and digital. You would certainly be well advised to ensure the compatibility of both mediums with any camera chosen.

There is no single camera that is the perfect choice for all photographic requirements. Either you specialize and restrict the kind of work you undertake to that which is possible with the camera you have chosen, or you purchase several different types of camera to cover all the requirements that are likely to be asked of you.

For general commercial work, photographers tend to switch between a monorail view camera, with its extensive camera movements (see section on 'Camera movements' later in this chapter), a medium-format SLR camera for people and action when it is essential to see through the camera lens at the moment of exposure, and 35 mm SLR cameras for their portability, speed and ease of use. The choice of equipment is narrowed when selecting it specifically for interior photography. It is certainly a false economy not to buy the very best equipment you can possibly afford, even if this means taking out a loan to do so. There are two reasons for this. First, the best equipment (usually the most expensive) does produce the best results. Even if you are unaware of the difference in quality now, it does not take long to become acutely aware of that difference. And second, it is essential to familiarize

yourself with your camera as soon as possible (which only comes through experience) so that its usage becomes second nature. The distraction you do not want is having to concentrate more on setting up the camera (from repeatedly having to upgrade your system) than on the subject of the photograph. Also, the better the equipment the more it retains its second-hand or collectable value, should you ever want to sell it.

Cameras

For high-quality interior work, 35 mm SLR cameras are largely unsuitable. Their small film size renders a poorer image quality than the larger formats, and makes perfect image construction difficult. They are also less practical because they lack the facility of interchangeable backs: the instant-print magazine back, an alternative film back and also the digital back.

It is essential to be able to fit an instant-print magazine back to the camera you choose. It enables you to take an instant picture of the precise image that will appear on film, which you then use to check the composition, the balance of lighting, the exposure and any unwanted flash reflections that may have been elusive to the naked eye. The peace of mind that instant-prints give the photographer cannot be overstated. Again, through experience, you learn how to

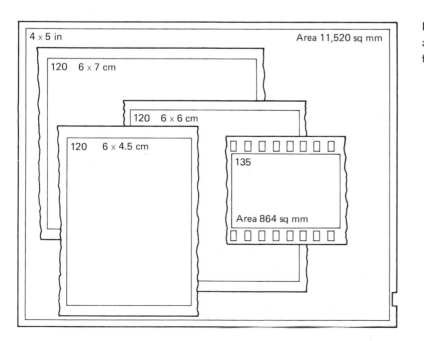

Figure 2.1 A comparison of the actual frame sizes of the different film formats readily available

'read' the instant-print image in terms of contrast and exposure. After making the necessary lighting and exposure changes, you can then take a further instant-print to check that those changes have produced the result you desire. Taking two instant-prints at different exposures also gives you an immediate indication of the actual effect on the image of the different exposures, be they, for example, a half or full stop apart.

The next choice, having eliminated the option of 35 mm cameras, is whether to buy a medium-format camera (which takes 10 or 12 exposures on 120 film, with an image size of 6 cm × 7 cm or 6 cm × 6 cm, respectively) or a large-format view camera that takes individual sheets of film, typically 5 in × 4 in or 10 in × 8 in. The larger the format, the smaller the depth of field for a given aperture, and therefore the greater the output of light needed to retain complete sharpness throughout the depth of the picture.

The advantages of the large-format view camera are obviously its higher picture quality and the use of its extensive camera movements. However, for most uses, this extra clarity in picture quality is unwarranted and, in a typical A4-sized publication, cannot be distinguished from its medium-format equivalent on the printed page. There is no doubt, though, that if the photos are to be enlarged to billboard poster proportions, then the large-format would definitely produce a sharper result.

The great disadvantage of the large-format camera, apart from its own extra weight and bulk, is the ancillary equipment it necessitates: more powerful (and therefore heavier) lighting equipment, the heaviest- and sturdiest-possible tripod, a changing bag for loading film, etc. The film and processing costs per shot are obviously much higher, and you do not have the facility for bracketing exposures which, for critical lighting on interiors, gives the client or editor a greater choice of lighting effect for the publication. While it is possible to 'read' a lot from an instant-print, it is not a perfect image, so exposure variations are the simplest way of achieving an appropriate choice on film.

The medium-format camera, however, with 10 or 12 exposures per film, does enable the photographer to bracket the exposures all on one film. The extra image quality over 35 mm, the instant-print magazine back facility on most medium-format cameras, and the modest light output needed to ensure sufficient depth of field in the photograph,

all make the medium-format camera the ideal choice for interior work.

There is, of course, a great variety of medium-format cameras available and again the choice must be made in accordance with the usage you will demand from it. There are two main categories of medium-format cameras: single-lens reflex (SLR) cameras and view cameras.

The SLR cameras, epitomized by the Hasselblad range, are suitable for most interior situations, are simple to operate and are very popular for this type of work. Their 6 cm × 6 cm format is favoured by some magazine picture editors who find a square format the most adaptable for cropping. The square format also enables a large square image to be printed across a double-page spread, leaving a margin for text on one side. Their main disadvantage is the low camera position that is sometimes needed when photographing interiors, to avoid

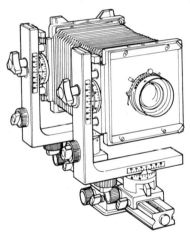

(a)

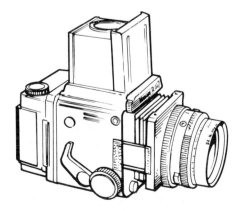

(b)

Figure 2.2 Two alternative camera types for interior photography: (a) the monorail view camera (available in both large and medium formats); and (b) the medium-format SLR

showing too much ceiling and not enough of the foreground, while retaining perfect verticals in the picture.

In order to avoid the common problem of diverging verticals in interior photography, it is essential not to tilt the film plane of the camera. The low position that is often adopted can appear unnatural in comparison with the eye-level view that we are used to in everyday life. Objects on tables can appear very oblique.

Some of these SLR cameras, including the Hasselblad and Mamiya ranges, can be fitted with a shift lens to overcome this problem to an extent. Shift lenses, also known as 'perspective control' (PC) lenses, are specially designed to enable a limited amount of the shift movements (described in the next section) on an otherwise fixed camera body. However, these lenses are usually extremely expensive and not very wide angle, thereby restricting the image to the focal length available.

Medium-format view cameras, on the other hand, have all the movements and adjustments of a large-format camera, combined with the versatility and bracketing ability of the medium-format camera. This is the ideal camera type for interior work, giving the flexibility of camera movements with lenses of all focal lengths, which is also perfect for exterior architectural work where control over converging verticals is of paramount importance. Such a consideration is sensible as many assignments for interior work include some exterior shots as well. It would therefore be prudent to consider exterior architectural usage when making your choice of camera. The Linhof 679 is a fine example of such a camera, and can be used with both film and digital backs. The more portable Linhof Technikardan is restricted to film use only, because of the nature of its construction.

The use of any type of view camera is, however, more complicated than that of an SLR, and this should be borne in mind as a factor by the less experienced photographer. Picture composition can be difficult until you are familiar with the camera, as the subject has to be viewed as an inverted and reversed image on the ground-glass focusing screen. The screen itself can only be viewed in darkness under a black cloth, and an independent magnifier is needed to achieve perfect focus. This can be avoided by using a monocular viewfinder (which will also partially correct the image inversion) but this will make an already fairly dark image on the focusing screen even darker. This is especially

significant for interior photography when light levels are typically much lower than for outdoor work.

The view camera can only be used mounted on a tripod – which would also be true of any camera used for the long exposures demanded by interior photography – and the focusing screen has to be replaced by the appropriate film back before you take a photograph. This, therefore, makes it impossible to view the image up to the precise moment of exposure, as you can with an SLR. Hence, its use is restricted when photographing people in interiors, or if there is any unpredictable movement likely within the picture area. In such circumstances, the SLR would be the better choice. To have both camera types available would give you the greatest flexibility.

Camera movements

The camera movements available on a view camera can be divided into two main categories: shift movements, which are parallel movements of the front and/or rear standard in a vertical or horizontal direction; and Scheimpflug adjustments, which are swing or tilt movements of either standard. Within the realm of interior photography, shift movements are the most widely used, though there are also uses for some Scheimpflug adjustments in exceptional circumstances.

Shift movements

Rising shifts are shifts in the vertical plane and are used to eliminate converging verticals in exterior architectural work or diverging verticals in interiors. The lens panel remains parallel to the focusing screen and is shifted either up or down from its neutral, central position.

This allows the focusing screen, and therefore the film back, to remain perfectly vertical, which is the essential requirement for perfect verticals in the recorded image. It means that if there is too much ceiling in the image of an interior when viewed from eye level with the film back vertical, the film back or lens panel can be shifted either up or down to include more foreground and less ceiling. This avoids having to tilt the camera downwards, causing the verticals to start to diverge, or having to lower the height of the camera to an unnaturally low elevation. While exaggerated converging or diverging verticals can add dramatic effect to a creative shot, slight convergences or divergences merely jar with the perfect verticals of the edge of the photograph and the printed page.

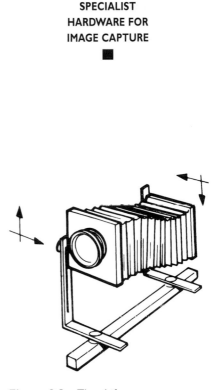

Figure 2.3 The shift movements available on a view camera are parallel movements of the front and/or rear standards. Rising shifts are shifts in the vertical plane and cross shifts are shifts in the horizontal plane

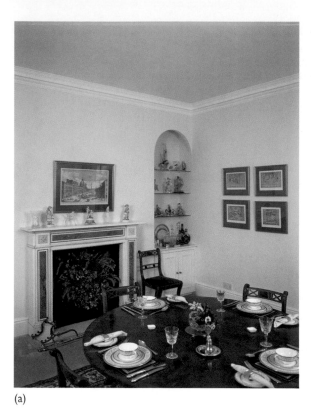

(a)

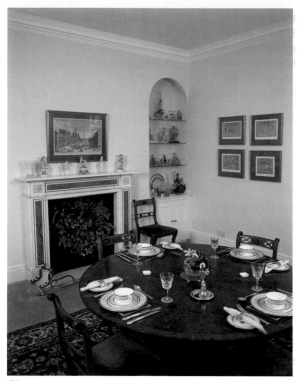

(b)

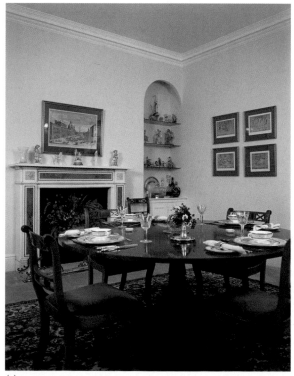

(c)

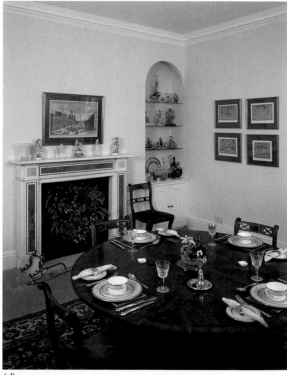

(d)

Figure 2.4 (*facing page*) The four photographs together demonstrate the main benefit of rising shifts in interior work. Photograph (a) shows the problem of photographing an interior from eye level with a fixed lens on an SLR: to retain perfect verticals the camera cannot be tilted, so too much ceiling is likely to appear in the image. Photograph (b) shows how the verticals diverge if the camera is tilted to include more of the foreground. The other alternative is to shoot from a lower elevation, as in photograph (c). This, though, can appear unnatural with objects on tables being shot at an oblique angle. However, we have got quite used to seeing interiors shot from this low vantage point, for the reasons described above. The most effective solution is to use a view camera, with a simple vertical shift of the lens panel or film plane to include more of the foreground and less of the ceiling – see photograph (d)

Cross shifts are shifts in the horizontal plane and, while not used with quite the frequency of rising shifts in interior photography, can still be very effective. Most commonly, cross shifts are renowned for their magical ability to photograph a mirror (or other highly reflective surface) from an apparently parallel, head-on position, without the image of the camera being reflected in it. This is because the camera is not directly in front of the mirror, but actually just to the side of it. Only the lens has been shifted sideways, to include a part of the image that is within the range of the image circle

Figure 2.5 The geometric distortion of the table in the foreground was minimized with the use of a cross shift. Because distortion is greater the further the subject is from the central optical axis of that lens, the camera was angled to centralize the table on the focusing screen. A cross shift was then used to decentralize it for the purpose of photographing the kitchen as a whole, instead of turning the camera. In this way, distortion of the foreground table was kept to a minimum

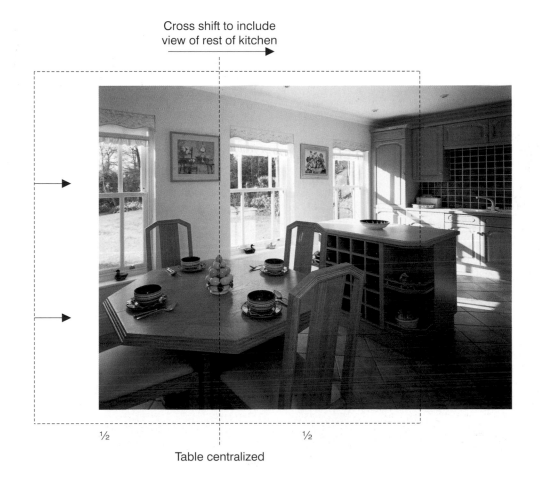

Cross shift to include
view of rest of kitchen

½ ½

Table centralized

of the lens, but not normally within the area of the focusing screen when all movements are neutrally centred.

This facility can also be used in interiors to partially correct the geometric distortion of objects close to a wide-angle lens. Because the distortion is greater the further the subject is from the central optical axis of that lens, one can centralize the foreground subject on the focusing screen (a table, for example) and use a cross shift to decentralize it for purposes of composition, instead of turning the camera. This will minimize the distortion in a decentralized composition, as demonstrated in Figure 2.5.

Cross shifts have a further use in retaining parallel horizontal lines in an image of an interior in just the same

Figure 2.6 Diagram (a) and photograph (b) show a typical fixed lens view of an interior. The camera back is out of parallel with the far wall, causing convergence of the horizontal lines of that wall. For the purposes of a clean architectural shot, this horizontal perspective distortion can be corrected by placing the camera parallel with the wall and using a cross shift of the lens instead, as in diagram (c) and photograph (d)

2.6 (a)

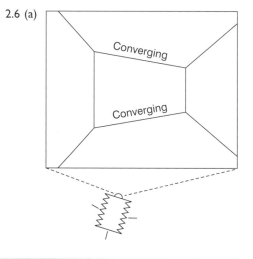

2.6 (b)

way that rising shifts prevent the convergence or divergence of verticals. As soon as the film plane ceases to be horizontally parallel to the back wall in a rectangular interior, the horizontal lines of the far wall in the picture will start to converge or diverge as a result of natural perspective. In other words, one-point perspective becomes two-point perspective in the horizontal plane. While such horizontal perspective 'distortion' is much more visually acceptable than vertical 'distortion', a cleaner, architecturally perfect image can be produced if you correct those too.

Within the limitations of the lens, you can use a combination of both rising and cross shifts to achieve desired results. The limitations of the lens, as a result of its limited

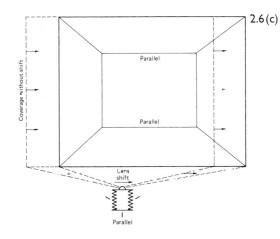

2.6 (c)

2.6 (d)

covering power, become quite apparent through experimentation on an instant-print when a black arc cuts off a corner of the image.

Scheimpflug adjustments

The adjustments made in accordance with the Scheimpflug principle are the swing and tilt movements on a view camera. The lens panel or the focusing screen, or both, are either swung around a vertical axis or tilted over a horizontal axis in order to control the plane of focus, and thereby the depth of field, without changing the shape or position of the image.

Figure 2.7 The Scheimpflug adjustments available on a view camera are the swing and tilt movements. The lens panel or focusing screen, or both, are either swung around a vertical axis (a) or tilted over a horizontal axis (b). This alters the plane of focus and can thereby increase the depth of field along one plane

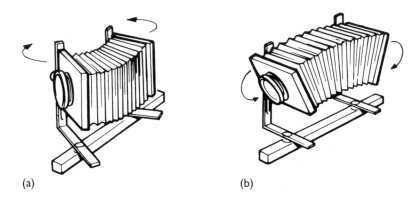

(a) (b)

In interior photography, swings are usefully employed for some detail shots: a wall or piece of furniture photographed close up from a horizontally oblique angle, for example. Without any movements, even with the smallest available aperture and an abundant light output, it might still be impossible to get both the foreground and the background in focus at the same time. However, by swinging the lens around the vertical axis a few degrees so that the subject plane, the focal plane (i.e., the focusing screen/film back plane) and the lens panel plane all intersect at an imaginary common line, you will maximize the depth of field along the subject plane.

According to the Scheimpflug principle, theoretically it makes no difference whether the front or rear standards, or a combination of the two, are adjusted, so long as the three planes intersect at a common line (see Figure 2.8). Practically speaking, however, it does make a difference. Swinging the lens panel is limited by the covering power of the lens, and any movement of the camera back alters the perspective to a degree, especially of the foreground subjects.

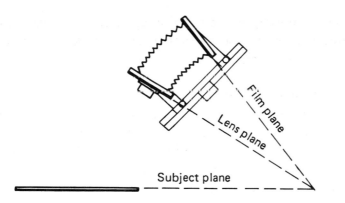

Subject plane

Figure 2.8 The Scheimpflug principle for maximizing depth of field. The film plane, lens plane and subject plane must all intersect at an imaginary common line, with an equal swing on both the front and rear standards

If maintaining the perspective is of paramount importance, then swinging the lens panel alone is the best way to increase depth of field. If precise perspective is not an issue, the way to achieve maximum depth of field along the oblique subject plane with maximum lens coverage and minimum lens distortion is to swing both the front and rear standards around the vertical axis equally, but in opposite directions, with the three planes still intersecting at an imaginary common line.

Tilts work in precisely the same way as swings, except around a horizontal axis, as the name suggests. This means that they would be perfect for altering the plane of focus to increase the depth of field across an empty floor: the foreground and background could be perfectly in focus at a relatively wide aperture. However, such instances are rare in the world of interior photography.

Scheimpflug adjustments can only control depth of field across one specific plane of focus. Apart from some detail shots, the depth of field required in most interior photography is fully three-dimensional, making Scheimpflug adjustments fairly useless. There would be no point in having the full depth of the floor in focus if all the furniture any height above it was out of focus.

So the best way to achieve depth of field throughout the full three-dimensions required for photographing an interior is to reduce the size of the aperture. If that still fails, you would have to use a lens of wider angle to create a smaller reproduction ratio – the smaller an object is reproduced on film, the greater the depth of field around it.

Extra camera facilities

It is ideal if the camera you choose has fitted spirit-levels. These are essential for retaining perfect verticals in your

shots. If, however, they are not fitted, it is possible either to buy one that clips into the flashgun accessory shoe (if there is a shoe) or to use one that is free-standing. The latter has a further use for levelling picture frames on the wall.

It is also sensible to have two film backs, as well as the instant-print magazine back (and possibly a digital back), for several reasons. It gives you the opportunity of shooting the same image on two different film types without having to shoot the whole roll; it covers you in case one back breaks down; it allows you to shoot just a few extra frames of the subject on a separate roll as a back-up in case of processing damage to the original film; and it enables you to work from one back to the next without having to stop and change the film.

Lenses

It is useful to have a reasonable selection of lenses of different focal lengths to enable you to cover the demands of interior and architectural work, and also to make results easier to achieve in awkward situations. For example, such a situation occurs when photographing small interiors. You may just be able to include the desired scope of the interior with a medium wide-angle lens, but only by crushing yourself into the corner of the room and then discovering that there is no suitable place out of camera view to place the flash unit. By using a very wide-angle lens (without curvilinear distortion – see next section) it becomes possible to move a couple of feet out of the corner, placing the flash unit either beside or just behind you, while retaining the full desired picture area.

Figure 2.9 The covering power of a very wide-angle lens can be usefully employed to create the extra space needed for both the photographer and any photographic lighting in a small interior, though the shift of camera position does affect the perspective

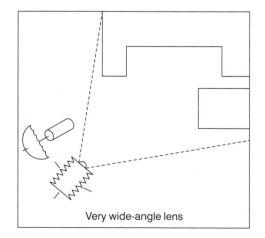

A practical complement of lenses would include a very wide-angled lens (47 mm on medium format); a medium wide-angled lens (65 mm on medium format); a standard lens (100 mm on medium format); and a short telephoto (180 mm on medium format). A further lens between the medium wide angle and the standard (a 75 mm or 85 mm, for example) would prove useful for exterior architectural work, as would occasionally a longer telephoto lens, but it is probably best to hire the latter on such occasions.

Lenses for digital photography

The main problem with all digital camera backs at the present time is the small size of the chip: 24 mm × 36 mm, exactly the size of the 35 mm format. Medium-format lenses used to focus on this small area effectively double their focal length with the result that the production of a distortion-free wide-angle lens is difficult to achieve without the addition of an optical condenser system.

There are several solutions to this wide-angle problem until such a time (if ever) that the size of the chip will match the size of the film format, thereby making film and digital backs truly interchangeable. Probably the best solution is to use a camera such as the Horseman DigiFlex II for extreme wide-angle shots. This is an SLR, designed to take a high-end digital camera back, which takes all Nikon F-mount lenses.

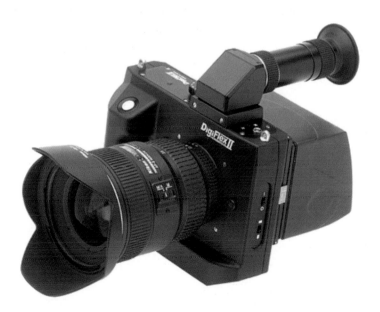

Figure 2.10 The Horseman DigiFlex II camera enables 35 mm wide-angle lenses to be used to full effect with a high-end digital back (photo courtesy of Robert White)

Because this enables regular 35 mm lenses to be used on what is effectively a 35 mm format, extreme wide-angle lenses can be used to their full advantage. What is lost is the ability to use camera movements with the wide-angle, creating potential problems of converging or diverging verticals. These can, however, be sorted out in Photoshop in the post-production process.

Another alternative is to shoot several images to create a panoramic effect, and then stitch the different images together with the appropriate software to create a single, wide-angle image.

Practical lens testing

All lenses used for professional photographic work are compound lenses: a combination of several different lens elements within a single lens barrel. This is because the image quality produced by a single lens element alone is quite inadequate for photographic purposes. Straight lines (which are obviously critical in any interior or architectural work) become curved, and if the image is sharply focused at the centre of the focal plane, the edges will be blurred. Only by combining several lens elements in a symmetrical configuration can these aberrations best be corrected.

That said, most medium-format lenses on the market are of a high standard and the best, usually the most expensive, are of a very high standard. However, for precision interior or architectural work, lenses should still be tested critically for any curvilinear distortion (the curving of straight lines) at the edges of the image. On the printed page, any curving of supposedly straight vertical or horizontal lines, especially at the edges of the image, becomes very apparent beside the perfectly squared edges of the picture on the page.

There are two types of curvilinear distortion: 'barrel distortion' and 'pincushion distortion' (see Figure 2.11), both caused by uneven magnification in the lens. Wide-angle lenses are prone to barrel distortion, especially at focal lengths approaching those of a fish-eye lens where such distortion is permissible; and long-focus lenses are prone to pincushion distortion. It is barrel distortion of wide-angle lenses that is our greatest concern in interior photography, and for which we need to test our lenses as critically as possible.

Barrel

Pincushion

Figure 2.11 The two types of curvilinear distortion caused by uneven magnification in the lens: 'barrel' and 'pincushion' distortion

A practical test is to photograph a perfectly straight line – a modern door frame, for example, would be a suitable subject (Figure 2.12) – at the outer limits of the image area: top, bottom and both sides. Place a flat rule across the floor at the bottom if necessary to provide the fourth straight line. When the film is processed, use a manufactured black card transparency mounting mask, with its perfect right angles, to analyse the results on a light box. Place the edge of the mask very close to the edge of the door frame in the image and visually compare the two for any bowing of straight lines beside the straight edges of the mask. These should be apparent to the naked eye on medium and large formats. If any barrel distortion is evident, you will have to reject the lens in favour of a better one. A similar test can be devised for

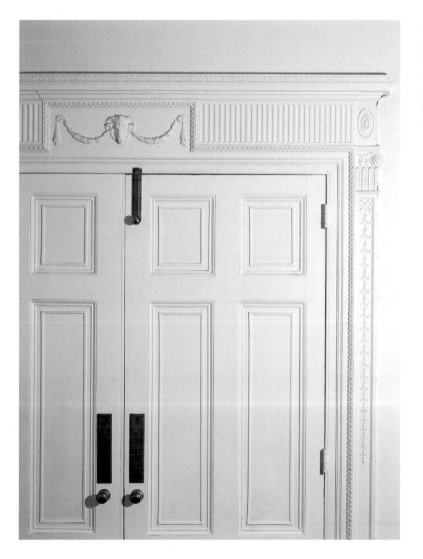

Figure 2.12 A doorframe is a suitable subject on which to test wide-angle lenses for curvilinear distortion. A mounting mask is placed alongside the verticals and horizontals of the door frame in the image to check for any curving

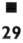

pincushion distortion on long-focus lenses of telephoto configuration.

Every lens manufacturer sets its own minimum image quality acceptance standards. Higher prices often mean stricter quality control, so to satisfy the critical demands likely to be made of you, it is sensible not to economize in this area.

3 RECORDING MEDIUMS: FILM VERSUS DIGITAL

The era of high quality digital imaging has now well and truly dawned and digital imaging has become the mainstream alternative to film and, in some areas, the dominant alternative. It is an area that all practicing photographers will be addressing seriously, if they have not already done so. The aim of this chapter is to clarify and lay bare the facts of traditional silver halide photography in comparison with those of modern digital technology.

Both film and digital image capture share many common characteristics. Both record light reflections received at the image plane onto a light-sensitive medium, with the objective of reproduction at some later stage. While the eventual output can appear very similar, the routes to achieve it are technologically quite different. The silver halide technology of traditional photography produces an analogue, continuous tone image where quality is limited by the grain size of the individual halide crystals. Digital images, by comparison, are electronically created, stepped-tone images based on the binary digital system where '0' is black and '1' is white, in its simplest form. An image is recorded as a framework of millions of 'pixels': the smallest distinct units, or picture elements, of a digital image that are encoded with the varying intensities of the colours red, green and blue that make up the image.

Being well versed in the practical aspects of film technology, as most of us are, this section will feature Ashley Morrison, a photographer with several years practical experience of shooting interiors digitally. He runs an extremely successful business, working for interior magazines, top companies, advertising agencies and design groups. Ninety-nine per cent of his work is shot digitally and he has no regrets over making the transition from film-based photography.

Ashley Morrison

Ashley Morrison runs AMP Studios with two associates in the beautiful countryside of Northern Ireland. Three-quarters of his work is shot on location and much of this is interiors work for the magazine and commercial markets. Until two years ago, most of his work was shot on a medium-format Hasselblad system using conventional film.

Figure 3.1 Ashley Morrison, digital interior photographer (photo copyright: AMP Studios)

Jumping in at the deep end, Ashley was the first UK photographer to buy the MegaVision T32, a three-shot area array back using the Philips 2k × 3k chip. The chip is rated at ISO 32 and an exposure is made through each of the RGB filters in turn, taking about 8 seconds. While designed primarily as a medium- and large-format studio back, the T32 can also be converted to a portable digital camera using an adaptor plate and 35 mm SLR lenses. This goes some way to overcoming the problem of wide-angle digital photography resulting from the small size of the chip (the size of a 35 mm film frame) relative to the covering power of lenses designed for medium and large formats. For interior location work, Ashley found that a Nikon 18 mm lens on the T32 actually gave him a wider field of view than the 40 mm lens on the Hasselblad. A degree of shift could also be employed using the Nikon 28 mm and 35 mm shift lenses.

Two years on and the T32 is now studio bound, sitting on a 5 in × 4 in Horseman, and largely used for pack shots. Ashley found the three-shot system good in quality but

difficult and frustrating to work with on location: nothing must move between exposures (not even trees blowing in the wind outside the window) and the natural light must remain constant. If the sun went behind the clouds between the three exposures, he had to start again. For his location work, the T32 has been replaced by the Phase One H20: a single capture digital back that creates high quality 48 Mb files from its 16 megapixel Kodak chip (36.9 mm × 36.9 mm in size). Rated at ISO 100 it can cope with long exposures of up to 16 seconds if required, producing massive files that can 'give a 5 in × 4 in tranny a good run for its money'. The H20 back is connected to a G3/500 PowerBook laptop computer with an internal CD writer, which enables the client to go away with all the images on CD at the end of the shoot if required. Under less rushed circumstances, Ashley prefers to view the images on the 21-inch screen back at the studio for fine adjustments in Photoshop before handing over the images.

A big bonus with digital, Ashley finds, is in the lighting. First, he can make white-balance adjustments to eliminate colour casts from artificial light sources, completely doing away with the need for a colour meter and any colour

Figure 3.2 Ashley Morrison working on location with the Phase One H20 digital back connected to a laptop computer (photo copyright: AMP Studios)

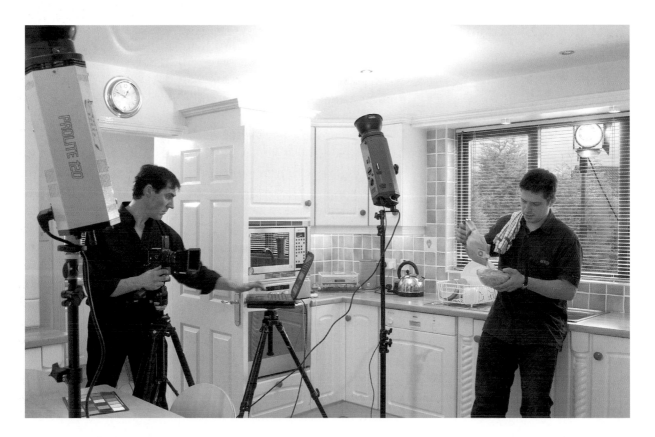

correction or compensation filters. Second, to overcome the problem of lighting difficult areas, he can shoot a series of shots, lighting each area separately and bringing them together in Photoshop. Being careful not to move the camera, change the aperture or point of focus, he can adjust exposure for different parts of the image by changing the shutter speed. He can even place lights in the middle of the frame if necessary, so long as he has taken a shot with the light out of frame on a different exposure. A copy and paste operation in Photoshop stitches the separate elements back into a coherent whole.

Despite the smaller image area of the CCD chip (than the 6 cm × 6 cm format of roll film), Ashley and his colleagues find that the standard Hasselblad lenses (the widest being the 40 mm) give sufficiently good coverage 95 per cent of the time. For the other 5 per cent he uses a Horseman DigiFlex II, which is effectively a 35 mm SLR camera body exclusively designed to take high-end digital backs and Nikon F-mount lenses, thereby making full use of the covering power of the wide-angle lenses available. With the DigiFlex II, Ashley uses a series of 35 mm SLR Nikon lenses, ranging from the widest at 18 mm to the 35 mm shift lens. The 28 mm shift lens yields excellent results, and is often used when joining two or more images together.

Figure 3.3 (*facing page*) A fine example of digital work by Ashley Morrison with the Phase One H20. Notice the sharp detail throughout the full depth of the image (photo copyright: AMP Studios)

In common with most interior and architectural photographers, Ashley believes in maintaining the verticality of the camera back to avoid the problem of diverging verticals from pointing the camera down slightly. If, however, the camera has to be tilted, he would correct it later in Photoshop using the 'skew' tool.

Finally, what Ashley sees as possibly the biggest advantage of digital over film is that he gets to see exactly what he has shot in a matter of seconds after exposing the image: no more guesswork or reliance on Polaroids! He supplies the client with CMYK or RGB files, along with 'proof' or 'match' inkjet prints.

A summary of the equipment that Ashley currently uses is listed below:

Location system.
- Cameras:
 - two Hasselblad 553s and a 503 body with 40, 50, 60, 80, 120, 150 and 250 mm CFi lenses;
 - Horseman DigiFlex II with 18, 24, 28 shift, 35 shift, 50, 55 macro, 85, 135 mm Nikon manual lenses;

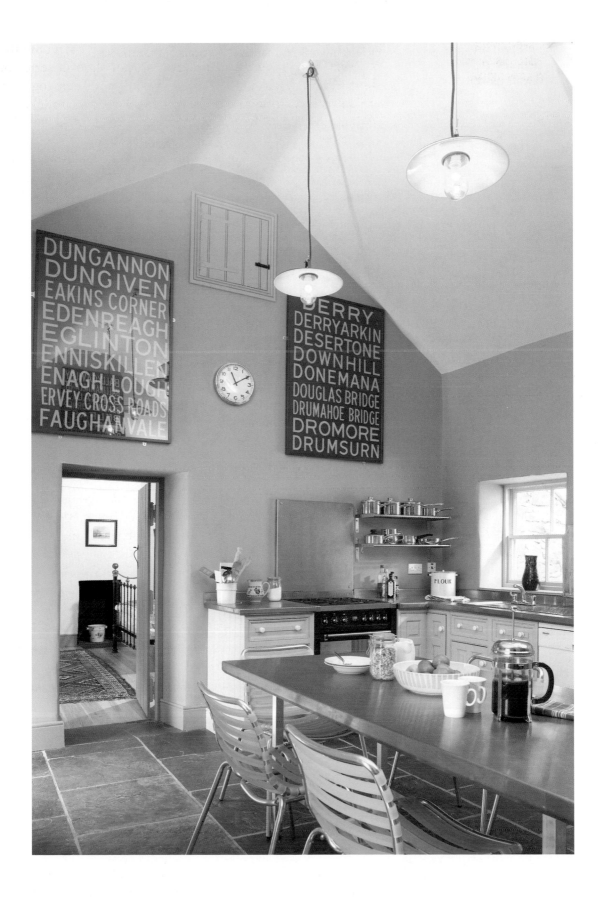

- Nikon FM2 body (manual film camera);
- Nikon D1X body with 24–70 mm and 80–200 mm zoom lenses.
- Digital system:
 - Phase One H20;
 - two G3/500 PowerBooks with 30 Gb hard drives, 512 Mb Ram, 8 × internal CD writer.
- Lighting:
 - Bowens Estime 3000AMF pack with three heads;
 - two 1200 Bowens Prolites;
 - two 1500 Bowens Esprit;
 - two 500 Bowens Esprit;
 - Bowens Pioneer kit, portable hand-held flash-gun system;
 - two Metz 45 hand-held flash-guns.

Studio system.
- A G3 and a G4 Macintosh, both with 80 Gb hard drives and 1 Gb of Ram;
- one 21 in and two 17 in Apple monitors;
- Epson 2000P printer;
- 24-speed FireWire CD writer (burns ten CMYK images onto a CD in 3 minutes).

The purpose of photography is to create high quality images, whatever the recording medium chosen. Choice of medium is determined by a number of different factors that need to be considered in turn: quality, cost, practicality, post-production, and the speed and efficiency of communication.

Quality

It is easy to take for granted the extremely high image quality of modern emulsions, a technology that has been perfected over more than a century of research and development. Inevitably it is these high standards that have set the benchmark for digital comparisons and it has taken a good 10 years for the digital quality to approach anything like the exacting standards of film.

There are certain specified minimum reprographic tolerances that must be adhered to for published image quality to be maintained. We all know that an image for a double-page magazine spread is sharper, more detailed and has better colour saturation if reproduced from a slow speed medium- or large-format transparency than from a fast 35 mm film, to

take the opposite extreme. This is because the resolution of the slower-speed, larger-format film is much higher: the halide grains are smaller than with a faster film, and the degree of magnification of the original to produce the image on the printed page is less because of the larger film size.

Similarly, digital file resolution is determined by the finite number of pixels per inch (ppi), or centimetre, used to construct the final print. The more pixels in an image, the finer the resolution. The resolution of digital cameras and backs is defined by the dimensions of the CCD, the silicon chip known as a Charge-Coupled Device. For example, the Phase One H20 digital back has effective CCD dimensions of 4080 pixels wide × 4080 pixels high = 16.65 million, or megapixels.

The repro industry works on the basis that the resolution of a digital file should be between one-and-a-half and twice the screen size used by the printing process. So a photo to be used in a 166-line screen magazine illustration requires a digital file with a resolution of between 250 and 332 pixels per inch, typically 300 ppi. Resolution (ppi) × physical

Figure 3.4 White balance adjustments with the digital back eliminate colour casts from artificial light sources which can be especially useful in industrial interiors (photo copyright: AMP Studios)

dimension = pixel size, so if the photo is to be printed to 8 in × 6 in, it requires a file containing 2400 × 1800 pixels = 4 320 000 pixels. 4.3 megapixels is beyond the range of many of the small digital cameras, but well within the limits of the high-end digital backs, such as the Phase One H20 used by Ashley Morrison, with 16 megapixels, as one would expect. Similarly, a full-bleed A4 magazine page (measuring approx. 11.65 in × 8.3 in) would require a 3500 × 2500 = 8.75 megapixel image, with a file size of 23 Mb RGB, or 30 Mb CMYK file (CMYK being the colours of the standard inks used in four-colour litho printing for brochures, books and magazines: Cyan, Magenta, Yellow and Black).

These backs also have a dynamic range of 12 *f*-stops, which is well in excess of conventional transparency materials, and the image has no grain, so quality in terms of both resolution and dynamic range compares well with that of film.

Cost

On first consideration, the cost of a high-end digital system can appear prohibitive: around five times as much as one would normally expect to pay for a basic medium-format camera system with conventional film backs. And if the digital back is not compatible with your existing camera system, you might need to buy a whole new system as well, not to mention the ancillary computer equipment for processing the images! All that money for a quality you can achieve quite simply with conventional film and the equipment you probably already own. Gigabytes of high quality data can easily be scanned off a conventional film.

But then, when you think about your annual expenditure on film and processing, suddenly the cost does not appear so massive. Repayments on a purchase loan can be viewed as a viable alternative to your regular monthly film and processing bills, so long as your inclusive fees remain at a similar level. To justify the switch from film to digital on economic grounds, you must compare these monthly costs with those of a loan over a fixed period, say three to five years, by which time the fast pace of digital developments may have made your equipment largely obsolete.

To conclude, despite the appearance of massive initial investment, the payments on a loan for digital equipment can be readily offset against the costs of film and processing. Post-production and CD costs can be charged to the client under a similar arrangement as with film and processing.

Practicality

This is probably the toughest comparison between the two technologies for location work. Film backs on medium format are simple to load and highly portable. While it is possible to use a digital back with a battery pack and memory card, it is preferable to be able to power it from the mains, and have it connected to a laptop for viewing. As such, this system is inevitably less portable than a simple roll film back, but it does have the advantage of immediate confirmation of the image you have taken. No more guesswork in terms of lighting and exposure, and even more reliable than instant-print film.

There is also the technical aspect of practicality in terms of the small chip size, as discussed in the last chapter. To shoot extreme wide-angle shots, either two or more images need to be stitched together as if creating a panoramic image, or an alternative camera body such as the Horseman DigiFlex II, which takes 35 mm lenses, is required. Any convergence or divergence of verticals would have to be corrected at the post-production stage, as opposed to the use of simple shift movements on a view camera when using the film back.

The immediate confirmation of results is a big practical advantage of digital technology. To be able to view the final image on screen takes all the guesswork out of instant-print interpretation, and there is, of course, no possibility of film damage occurring during processing. What you see is what you have got: this can be approved by the client instantly, or changed as necessary and re-shot.

Post-production

This is one area where digital wins hands-down over film. A processed film *is* the final product, unless it is to be scanned into digital form and reworked as a digital image. The digital image, on the other hand, is a raw file that can be manipulated in Photoshop, for example, to any degree. Colour balance, contrast, even perspective can be adjusted to suit the image, and retouching the image to remove unwanted marks or reflections is a simple operation. The image can be burnt onto a CD and copied perfectly any number of times with no deterioration of quality.

The only possible advantage of film over digital in this area is one of tangibility. It is still easier to view a set of transparencies on a light box, or even by holding them up

to a window, than it is to load a disc and view the results on a computer screen.

Speed and efficiency of communication

When it comes to the speed and efficiency of communication, digital comes into its own. Images can be shot and transmitted via a dedicated digital telephone line within minutes: no more need for the processing chemistry and the manual delivery of film or prints. Fantastic for press work, and low resolution Web images, but with severe limitations for high quality magazine/marketing work, where file sizes to achieve the necessary quality are so large that even sending the images via dedicated digital lines is impractical. In these situations the images have to be burnt onto a CD and, as with film, delivered manually. So digital saves on the processing time, but not necessarily the delivery time, especially in the case of interiors.

On a personal note, I find the combination of shooting high quality shots for publication on film, with low resolution digital snapshots for instant Web use or proof layout, a useful compromise.

Clients, on the whole, are still not yet demanding digital originals because the scanning of conventional transparencies is simple and the quality consistently high. Further technological advances and standardization, combined with lower prices as a result of increased demand, will trigger the acceleration of the switch from film to digital. It is important that any hardware purchased now will be compatible with both technologies in the future.

Film

A golden rule with film choice is to keep it simple. Get to know, experience and understand just one or two films that will become your staple photographic diet for this kind of work. Not having to worry, or even think, about your choice of film is almost as important as being familiar with your camera. It enables you to concentrate fully on creating the picture without being distracted by the mechanics.

In many other branches of photography, photographers have to compromise film speed with quality in order to capture any movement with sufficient sharpness. The majority of interior photographs are devoid of subject movement and demand long exposures with the use of a tripod. Interior photographers are therefore afforded the luxury of using high

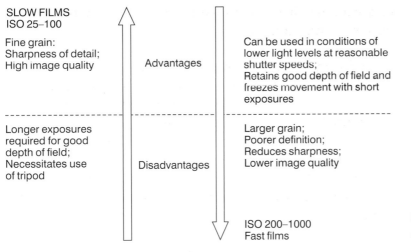

SLOW FILMS
ISO 25–100

Fine grain:
Sharpness of detail;
High image quality

Advantages

Can be used in conditions of
lower light levels at reasonable
shutter speeds;
Retains good depth of field and
freezes movement with short
exposures

Longer exposures
required for good
depth of field;
Necessitates use
of tripod

Disadvantages

Larger grain;
Poorer definition;
Reduces sharpness;
Lower image quality

ISO 200–1000
Fast films

Figure 3.5 The qualities of films of
different speeds

quality slow- or medium-speed films as their regular stock
(see Figure 3.5). The slower the film, the finer the grain and
therefore the sharper the images for reproduction.

Colour transparency film

Colour transparency film is the popular choice of most
commercial photographers, and is widely used for the
purpose of mechanical reproduction. It gives an original
image, as opposed to a print from a negative that is
necessarily once-removed from the original. Since the final
published image is twice further removed from the original
supplied by the photographer, it is essential to give the
publisher an original of the highest possible quality from
which to work. Correctly exposed transparency film has a
wider density range, richer gradation and deeper colour
saturation than negative film. It is not subject to printing
differences, and it acts as a ready guide to scanner operators
for checking test prints.

Colour transparency films are available in two varieties:
daylight balanced and tungsten balanced; both can be useful
for interior work. A slow- or medium-speed film for general
purpose interior work would be a professional daylight
balanced film rated at ISO 100, for example a Fuji
Fujichrome or Kodak Ektachrome transparency material.
This type of film is extremely versatile and of very high
quality. It requires no filtration when daylight through
windows combined with flash is the primary light source, and
the latest films suffer no significant reciprocity failure for
exposures up to 2 minutes. The precise film choice you make

is a personal decision to be arrived at by direct comparison of the same image on several similar films by different manufacturers.

Tungsten-balanced (type B) film, rated at ISO 64, is useful for interiors that are lit entirely, or largely, by tungsten lighting as it requires little or no filtration for perfect colour rendition (see Figure 6.6). All daylight-balanced and tungsten-balanced transparency films use the Kodak E-6 process for development (other than Kodachrome films, which have to be processed almost exclusively by Kodak themselves). This is an 11-stage, 1-hour process (inclusive of drying time), with a usual turnaround time of 2–3 hours in a professional laboratory.

Colour negative film

Although excellent colour prints can be produced from a colour transparency either directly (positive to positive) or indirectly (via an internegative stage), colour negative film

Figure 3.6 The different routes available from film to colour print

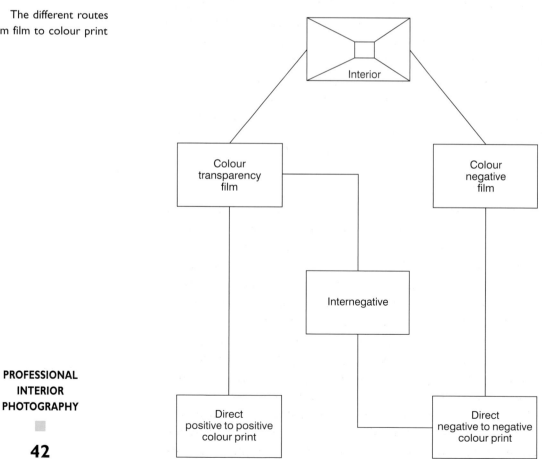

remains the most popular option when colour prints are the only desired end-product of a shoot. The quality is obviously better than going via an extra internegative stage, and cheaper for long print runs than direct positive-to-positive prints from a transparency. The image quality is also quite different, and therefore choice of printing from negative or transparency is dependent both on requirements and personal preference. Exposure accuracy is less of a problem with negative films since they have a wider exposure latitude.

Again, a slow or medium film speed would be appropriate for interior work, though for exposures over 4 seconds it is still susceptible to reciprocity failure. Colour balance on negative film is not as critical as that on transparency film, as minor colour variations at the time of exposure can be filtered to produce the desired colour balance at the printing stage. Since negative film alone cannot by definition produce a positive image for viewing, the quality of the final image is as dependent on the paper on which it is printed as the film on which it was taken. For these reasons, experimentation under the same conditions is the best route for discovering your personal choice of film/paper combination, concentrating on the comparison of tone, detail sharpness, grain size, and the richness and accuracy of the colour rendition.

Colour negative films are developed using the Kodak C-41 process. This is a seven-stage process that takes approximately 45 minutes (inclusive of drying time), with a turnaround time of anything from 1 hour in a professional laboratory.

Black-and-white film

The major uses for black-and-white film in the realm of interior photography are for newspapers and the archival recording of buildings. This is the preferred film type of the National Monuments Record, for example. Black-and-white films have proved their durability over a long period of time if stored correctly, and are not prone to the potential fading of synthetic dyes in colour films. Furthermore, photographic archives on black-and-white film and paper are more consistent for the direct comparison of shots taken at different times, than a variety of different colour films with slightly different colour balances and varying degrees of fading. This in itself could be an unnecessary distraction.

In comparison with colour film, and with transparency film in particular, black-and-white negative film with its

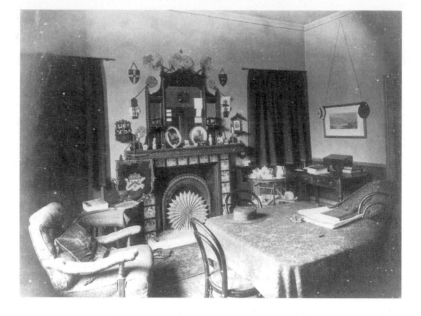

Figure 3.7 Black-and-white film is the ideal medium for the archival recording of buildings. It is more consistent for the direct comparison of shots, as it avoids the distraction of varying colour balances in partially faded colour prints. This photograph was taken of a student's room at Trinity College, Cambridge in the 1880s, by William Dunn

single-layer of emulsion is both forgiving and simple to use. It is tolerant of minor exposure variations, and obviously avoids any problems caused by unwanted colour casts from artificial light sources and those created by mixed lighting conditions. It is also flexible in the way it can be processed and printed, enabling a wide range of options for the final print in terms of grain, contrast and sharpness.

Again, a slow- or medium-speed emulsion is recommended for everyday use, typically ISO 100–ISO 125. However, for precision work with the finest detail, the sharpest film with the smallest grain is a slow film with a typical speed rating of ISO 25 or ISO 32, used in conjunction with a fine-grain developer. These slower films have slightly higher contrast than the medium-speed emulsions, though this can be easily adjusted at the printing stage.

Extra photographic lighting is usually necessary when photographing interiors to reduce the contrast of the natural daylight to a level that can be fully recorded on film. While this is usually essential for colour film, and preferable with black-and-white film, contrast on the latter can be controlled to a degree by overexposing the film in the camera and correspondingly reducing the development time. Contrast can be further reduced or enhanced at the printing stage, depending on the contrast balance of the printing paper you choose. If complicated exposure/development variations are likely to be a regular part of your interior work, it would

make sense to process and print your own films as your experience will be the best guide to achieving perfect results.

Instant-print film

The importance of instant-print film, available in both colour and black-and-white, cannot be overstated. When used in an instant-print magazine back that has been interchanged with the regular film back on the camera, it can produce a positive image of the precise picture you are intending to take, only 90 seconds after exposure. It enables you to check for correct lighting, exposure and unwanted flash reflections, giving you unprecedented confidence in the resultant final image.

There are several types of instant-print film available, matched to the film speeds of the popular film types. Polaroid Polacolor 669 or 679 film are daylight-balanced colour films rated at ISO 100 – ideal when used in conjunction with ISO 100 daylight-balanced transparency film. These produce a positive image 90 seconds after exposure at temperatures between 21°C and 35°C. Processing time is increased to 120 seconds at 16°C. Similarly, Fuji FP-lOOC film is also a daylight-balanced colour film rated at ISO 100, varying the process time with the ambient temperature from 180 seconds at 15°C to 60 seconds at 35°C, and the standard 90-second development time at 25°C. Fuji suggest a two-minute development time when placed under your arm to be warmed by your body heat.

When working with ISO 64 tungsten-balanced film, the perfectly matched instant-print film is Polaroid Polacolor 64 Tungsten film. With this film, film speed is nominally kept constant along with processing times, but exposure adjustments of a third of a stop must be made according to the ambient temperature.

Black-and-white instant-print films are also available, Polaroid's Polapan Pro 100 being a popular choice. Some photographers actually prefer to use this black-and-white material even when shooting on colour transparency. They find it both more useful for assessing the tonal contrast of light to shade in the image (for fill-in lighting requirements), and more accurate as an exposure guide than equivalent colour materials.

Matching the instant-print film to the transparency film to be used overcomes the need to make complicated exposure

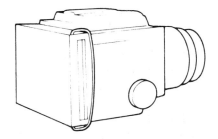

Figure 3.8 The instant-print magazine back attached to a medium-format SLR camera. It produces a positive image only 90 seconds after exposure. This enables you to check the effect of both the lighting and exposure. It also shows up any unwanted flash reflections that can be eliminated before finally shooting the image on film

Figure 3.9 The instant-print magazine back sometimes produces a larger image area than the transparency or negative film size allows. A transparency-sized mask enables you to crop the image to the size of the final transparency, for viewing. You can also move the mask around the instant-print image to check your composition

calculations between films of different speeds and colour balances and therefore makes a lot of sense, but is not obligatory. Precise processing times, film speed changes or exposure adjustments are clearly detailed on each pack.

The instant-print magazine back on a camera sometimes produces a larger image area than the transparency film size allows. Therefore it is important to carry a transparency-sized mask, preferably the type used for eventually mounting the transparency, as this will show you the precise image area that will be recorded on film. Any extraneous objects, cables, reflections or flash units outside this area on the instant-print are obviously not worth worrying about. The advantage of having the larger image area on the instant-print is that it enables you to shift the mask around to check that composition for the film area is perfect. By using this technique you can see that shifting the mask up and increasing the ceiling area may make a more dramatic shot, or shifting the mask down and including more of the floor may favourably expand the apparent size of the floor area relative to the height of the ceiling. When this is the case, corresponding lens shifts can easily be made on a view camera by shifting the front or rear standard up or down, without affecting the focus.

Storage

For the best possible results from your choice of film, you should use film as fresh as possible to render a neutral colour balance when processed. As film ages, its overall colour balance shifts, it becomes less sensitive to light and its contrast diminishes. With general-purpose amateur films, the manufacturers assume that it will be an average of three months before the film will be used. It is therefore created to have a neutral colour balance after ageing for three months at room temperature. With 'professional' films, on the other hand, the colour balance is neutral at the time of production and should therefore be refrigerated until used to halt the ageing process. This means that when using a refrigerated 'professional' film, the photographer can be confident that the overall colour balance of the film will be as neutral as possible.

In case of any minor factory variations of colour balance, it is best to shoot each assignment with film that has the same batch number (shown on the side of the box along with the expiry date) in order to achieve consistent results. This is most easily done by buying film in bulk.

4 LIGHTING EQUIPMENT, METERS AND FILTERS

Having chosen a suitable camera and selected an appropriate set of lenses, it is time to turn your attention to the rest of the supporting equipment that is necessary for photographing interiors: lighting, meters and filters. Again, it is easy to be dazzled by the vast array of equipment available, and it is therefore important to be clear about the equipment you actually need when starting in this field, and that which might be desirable at a later date once you are more experienced and eager to fine-tune your technique. For example, while a pair of photographic lights (probably flash units along with a flash meter) are essential, an independent light meter is unnecessary if you already possess a 35 mm camera with a built-in light meter. A colour meter, along with a comprehensive set of colour compensating filters, is probably one of the last pieces of equipment you would need to buy as its use is specialized and not absolutely necessary for most general interior photography.

Lighting

Supplementary lighting is usually necessary for photographing most interiors, for reasons explained in Chapter 5.

Photographic lighting can broadly be divided into two main categories: flash and tungsten. Flash is the best choice to simulate natural, white daylight in terms of colour temperature. Where daylight is dominant in an interior, flash is the perfect 'fill-in' light for the most natural appearance.

Tungsten light, on the other hand, is a redder, 'warmer' light source. While it can be used as a 'fill-in' light source in the rare situations of exclusively tungsten available light (and the image recorded on a tungsten-balanced film), it can also be filtered to approximate white light. However, its most

effective use in interior photography is for dramatic sunshine-effect lighting. It can be filtered in varying degrees to achieve the required effect of harsh, yellow/orange sunshine at different times of day. The light from a winter sun in early morning and late afternoon is much redder than a summer sun at noon which is considered to be white, and its angle lower, penetrating further into the room. This can also be suitably emulated by lowering the height of the light stand.

Flash

Flash is the most practical and useful form of photographic lighting for interior work. As already mentioned, it closely approximates white daylight, without any filtration and, since daylight is often the dominant light source in interiors, this creates a natural and unobtrusive supplementary light

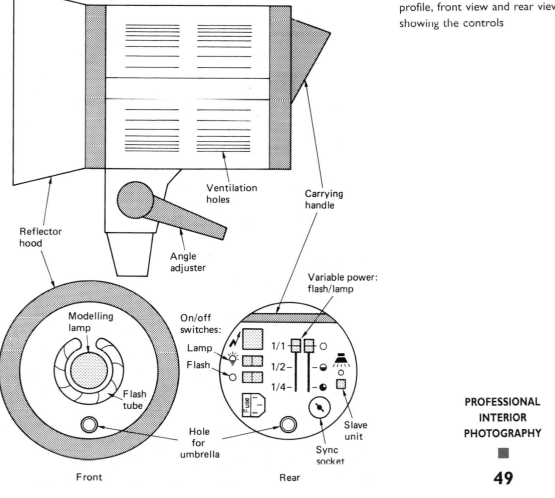

Figure 4.1 The integral flash unit: the profile, front view and rear view showing the controls

source when bounced off a white umbrella or white wall, or fired through a soft-box.

Flash lighting comes in various forms: from a simple on-camera flashgun, through integral mains units, to flash heads powered by a studio power pack. Since the interior photography that is the subject of this book is by definition location work, portability is clearly an important factor in choice of flash lighting.

By and large, the output of a portable flashgun will be too low for the power necessary for lighting interiors, especially since the flash is usually not used direct but is reflected off a white surface. This effectively reduces the flash output that reaches the subject by several stops. However, it is handy to carry a portable flashgun in your camera bag as it is small and can be used with a 'slave unit' (a flash-sensitive eye for triggering the unit when used in conjunction with one or more other units) to illuminate dark corners or spaces, while actually hidden within the picture area itself. The flashgun fires the instant it receives light from another flash source.

In terms of portability, a studio power pack with flash heads is impractical. The pack is large, heavy and unwieldy and necessitates extra, sometimes obtrusive, cabling. The most popular choice is a set of integral mains flash units which, although individually heavier as heads, are both more portable and simpler to use. The power of these heads ranges from the weakest at around 200 joules, to the most powerful (and accordingly the heaviest) at around 800 joules. Heads with a variable power up to 500 joules give a convenient output for lighting interiors. In many residential and small-scale commercial interiors, one or two heads are often sufficient, though it is sensible to carry at least three heads to enable you to cope with most situations.

The integral flash unit consists of a circular flash tube surrounding a modelling lamp (for previewing the effect of the light) at one end of the housing, with controls at the opposite end. The controls usually consist of a mains supply switch, two knobs for varying the output of the flash and modelling lamp, and a slave unit. Apart from having a synchronization cable from one of the units connected to the camera, every other unit only has to be connected to a regular 13-amp socket. The flash-sensitive slave units trigger their firing as soon as the first unit is fired by the camera. This obviously happens at the speed of light, so there are no

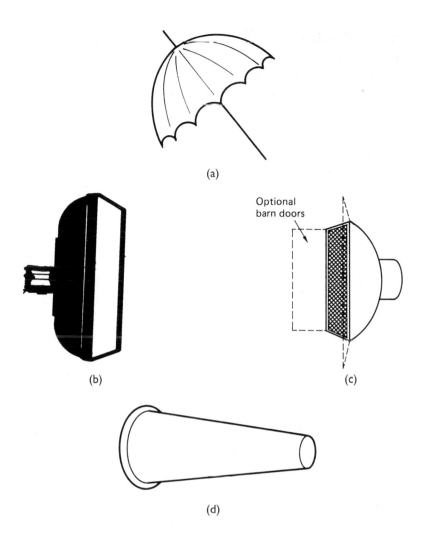

(a)

Optional
barn doors

(b) (c)

(d)

Figure 4.2 Various flash unit attachments for different lighting effects. An umbrella (a) for wide, soft fill-in light; a soft-box (b) for more controlled and directional fill-in light; a diffuser (c) for highlighting with soft, square light; and a snoot (d) for a harsh, directional circular spot of light

worries over the length of the exposure at shutter speeds slower than, say, $\frac{1}{250}$ second.

When used for interior photography, the modelling lamps on the flash units give the photographer a rough idea of the quality and direction of light, and are useful to check visually for any unwanted reflections in the picture. They do not give a correct indication of the intensity of the flash output in relation to the available light. This can only be checked by exposure calculation followed by shooting an instant-print test shot.

All integral flash units have a hole through them from one end to the other which acts as a socket for attaching umbrella reflectors. Umbrellas are essential ancillary equipment, with black-backed white ones being the most useful for interior photography, and gold umbrellas occasionally for special effects. A soft-box is used in preference to umbrellas

by some photographers because of its reduced light spill, and a variety of diffuser and snoot attachments are available that can be useful for highlighting specific areas within the image.

Finally, lightweight collapsible flash stands are necessary for mounting the flash units. These usually extend to a height of around 2.5 metres (8 feet), and collapse to fit into a tailor-made shoulder bag that should hold three stands and three umbrellas. The flash units themselves are best protected and most portable in the specially made cases available. These are commonly designed to hold two or three units.

Tungsten

Tungsten lighting plays a secondary role in interior photography, and as such is not essential equipment when starting in this field. It can, however, be useful for supplementary special-effects lighting: for creating artificial sunshine on an otherwise cloudy and overcast day; or to create the effect of sunshine through a window when no such window actually exists. It has to be used cautiously and judiciously to be effective, or its artificial nature quickly becomes apparent.

There are a variety of tungsten lamps available in many different housings. The cheaper, traditional short-life photo-floods have given way to the more expensive, more powerful and more efficient tungsten-halogen lamps, available in wattages from 200 to 2000 watts for general photographic

Figure 4.3 Creating the effect of sunshine on an overcast day. A 2000-watt tungsten-halogen lamp was placed outside the window (with a half-blue colour correction gel placed in front of it for partial colour correction)

purposes. The most portable variety for location work consist of a halogen lamp surrounded by a reflector. The position of the bulb is adjustable from 'spot' to 'flood', i.e., the deeper the bulb is seated in the reflector hood the more concentrated the beam light ('spot'); and the shallower the bulb is seated, the broader the spread of light ('flood'). The beam of light can then be shaped with the adjustment of 'barn doors', four hinged shades attached to the front of the reflector. These lights can be used either indoors as window-shaped spots, or from outside through a window as sun-mimicking floods. A pair of such lamps, rated at around 1000 watts, is a useful and effective complement to a set of flash units: desirable if not essential.

A less portable, more weighty alternative to these relatively simple lamps is the focusing spot-lamp. This consists of a halogen bulb and a focusing lens in a long and heavy housing. The relative positions of bulb to reflector and lens to bulb can be adjusted to alter the beam diameter and control edge sharpness of the light spot. 'Gobos', or metal-patterned inserts, can be added between the lamp and the lens with an effect similar to that of a projector. Light passes through the special effect gobo (available in various window and foliage designs) in the same way a transparency is projected, with the image focused or blurred onto a wall/

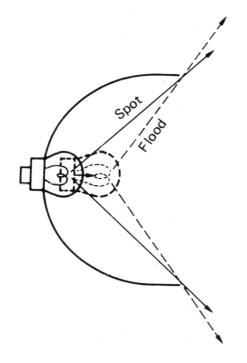

Figure 4.4 The tungsten-halogen lamp. The bulb position can be adjusted within the housing to create either a 'spot' or 'flood' effect. The deeper the bulb is seated in the reflector hood, the more concentrated the beam of light ('spot'); the shallower the bulb is seated, the broader the spread of light ('flood')

floor to give the effect of sunshine through a window, or sunshine through a plant. Though effective in the truest sense of artificial lighting, focusing spots are probably better suited to studio work because of their artificiality, weight and also the weight of the stand needed to support one of these lamps. It is also worth mentioning that Broncolor make a focusing spot flash head, which has the advantage of running at a cool temperature. This means that home-made cardboard gobos can be simply crafted to suit any situation.

Colour correction filters for tungsten

All tungsten lamps need a selection of colour correction filters to balance the colour temperature of their 'warm' light towards that of photographic daylight, depending on the degree of 'warmth' required from this artificial sunlight. It is rare to filter this effect completely to white as a degree of warmth gives the most natural appearance.

These filters come in the form of coloured plastic or gelatin sheeting which can be cut to any shape or size to fit over any lamp. Full Blue corrects tungsten (3200 K) to daylight (5500 K); also available are $\frac{1}{2}$, $\frac{1}{3}$, $\frac{1}{4}$ and $\frac{1}{8}$ Blue for varying degrees of correction. Either a $\frac{1}{2}$ Blue or a $\frac{1}{2} + \frac{1}{4}$ Blue, make a good compromise between colour correction and a desirable suggestion of warmth in the light.

Meters

There are three different types of meter that are used in interior photography: a light meter, a flash meter and a colour meter. The first two are essential equipment and sometimes come in combined form, while the latter is optional, for critical work.

Light meters

A light meter is necessary for measuring the 'natural' available light in an interior before any supplementary photographic lighting is added. Since this is often treated as the dominant light source for the most natural appearance of a room, its correct measurement is of fundamental importance.

A hand-held meter can measure light in two ways. It can either record a direct reflected reading, which measures the quantity of light reflected off the subject (its brightness or luminance); or it can record an incident reading to measure the amount of light falling on the subject. Incident readings

are more consistent as they are not affected by the reflectivity of the materials onto which the light is falling. However, whether reflected or incident readings are taken, an average brightness must be deduced from the whole of the subject area. While a spot meter, which measures reflected light with a 1° angle of measurement, is useful for determining the variations in light level across an interior, the centre-weighted metering system in a 35 mm SLR camera is useful for deducing a working average from several different readings across the picture area.

Whichever type of light meter is chosen, experience of it is the best way of achieving consistent results. If you are used to 'reading' the metering system of a 35 mm SLR camera, then this is probably your best choice. If not, incident readings on a hand-held meter are equally effective.

Flash meters

Flash meters are a specific type of light meter that are used to measure the strength of the very short, bright bursts of light emitted from a flash unit. They usually record only incident readings, measuring the intensity of the light reaching the subject, and displaying the necessary aperture for average exposure at preset shutter and film speeds. While this is an essential piece of equipment, it does not need to be the best or most expensive on the market: the cheaper meters still measure the flash intensity accurately. With interior photography especially, the meter readings need only act as a guide since the flash is often the secondary light source to the dominant available light already in the room.

Colour meters

A colour meter measures the colour quality of light in an interior, relative to the film type being used. It records the colour temperature, any colour casts and calculates the filters needed to balance the colour of the available light to the particular film type in use. Needless to say, this is an unnecessary item if working digitally where a white balance can be set, and any colour casts removed, in post-production.

Incident light readings are taken from within the picture area towards the camera. The light passes through a diffuser onto three separate silicon photocells, individually sensitive to blue, green and red light, respectively. The relative responses of these photocells to this light is compared, displaying a read-out of any necessary filtration required.

Figure 4.5 Colour meter. Light passes through the diffuser at the top onto three separate silicon photocells, individually sensitive to blue, green and red light, respectively. The relative responses to this light of these photocells are compared, displaying a readout of any necessary filtration required

It is an expensive piece of equipment and fortunately its use is not necessary for most everyday situations. Tables for colour correction and compensation (see Figure 4.6 and Table 7.1) are readily available as guides to the filtration required for various light sources. However, for precision interior work where perfect colour reproduction is critical, this is the best tool for the job.

Filters

Photographic filters are coloured or textured discs of glass, plastic or gelatin placed in front of the lens in order to modify the colour or quality of light passing through it onto the film plane, thereby altering or enhancing the recorded image.

Filters can broadly be divided into three categories: colour correction filters, colour compensation filters and special effects filters. Colour correction and compensation filters balance the colour of the light source with the type of film being used, and therefore are of fundamental importance for interior photography. Special effects filters tend to be of limited use, though a polarizer can be useful for cutting out daylight reflections on paintings and other reflective surfaces.

Colour correction filters

Colour correction filters alter the 'colour temperature' of the light passing through the lens. Therefore they are either a strength of amber, to 'warm' up the light (in the colloquial sense), or a strength of blue to 'cool' it down. They are necessary because, while the human eye readily compensates for variations in colour temperature, colour film tends to emphasize it.

The 'colour temperature' scale, in degrees Kelvin, measures the colour of the light radiated by an incandescent light source (i.e., one that glows from being heated) when heated to different temperatures. At the bottom end of the scale, these incandescent light sources include candlelight with a low colour temperature of 1930 K and domestic tungsten light bulbs with a medium-low colour temperature of 2900 K for a 100-watt bulb. Light sources with a low colour temperature radiate colours from deep red, through orange, to yellow and finally yellowish-white. They therefore require blue filtration to correct the balance of their colour temperature to that of photographic daylight. In the middle of the scale is direct noon sunlight, or 'photographic'

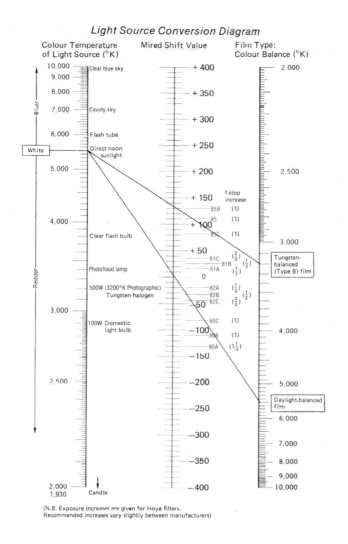

Light Source Conversion Diagram

Figure 4.6 Colour correction filters. Draw a straight line between the colour temperature of a light source on the left, and the film type in use on the right. The necessary filter to correct the colour balance is indicated at the point where the line crosses the central scale. This also shows the mired shift value together with the necessary exposure increase in *f*-stops

daylight, at 5500 K: in photographic terms, neutral white light to which all general-purpose colour films are balanced.

Light sources with colour temperatures higher than 5500 K include sunlight filtered through an overcast sky at between 6000 K and 7000 K, to light reflected from a clear blue sky (in open shade, not in direct sunlight) at between 10 000 K and 15 000 K. These light sources with high colour temperatures radiate colours from bluish-white to blue, and therefore require amber filtration to correct the balance of their colour temperatures to that of photographic daylight.

The effects of colour correction filters are not measured in Kelvin because of the logarithmic nature of the scale which would give the same filtration different values for different source colour temperatures. Instead, they are measured in

mired shifts (shifts of MIcro REciprocal Degree, i.e., one million divided by the colour temperature in Kelvin). This is a more convenient means for calculating the necessary strength of filtration in order to correct the colour temperature of a particular light source, as it gives the filter a constant value. Thus, the colour correction filters for positive mired shifts above zero are strengths of amber (the 81- and 85-series), and for negative mired shifts are strengths of blue (the 80- and 82-series).

For example, using a daylight-balanced film, balanced for white light at 5500 K (a mired value of 1 000 000 divided by 5500 = 182) with tungsten photographic lighting at 3200 K (a mired value of 1 000 000 divided by 3200 = 312) the difference and incompatibility between the two is 182 – 312 = –130 mireds. Reading from the scale in Figure 4.6, a blue 80A filter would be the appropriate filtration necessary to correct the colour temperature of the light source to that of the film.

Professional colour transparency films are available in a choice of only two different colour balances: daylight-balanced (5500 K) film, the most common, for use when daylight or flash is the dominant light source; and tungsten-balanced (3200 K) film where tungsten light is the primary source. Colour correction filters can be used to balance the colour temperature of particular light sources with the film type being used, as described in the example above. A more frequent use of colour correction filters is to convert the balance of a daylight film to tungsten, and vice versa. The strong colour correction filters used specifically for this, are known as 'colour conversion' filters.

The 80A filter (deep blue) will convert a daylight-balanced film for use in tungsten lighting, as in our example; and the 85B filter (strong amber) will convert a tungsten-balanced film for use in daylight or with flash.

Colour compensating filters

Colour compensating filters, usually made of thin gelatin, are similar to colour correction filters but are more wide ranging in the sense that they are available in the six colours of the photographic process: red (R), green (G) and blue (B), and their complementary opposites cyan (C), magenta (M) and yellow (Y), all in varying densities. In combination or alone, these filters can finely tune the colour balance of almost any lighting situation when used in conjunction with a colour

meter (an instrument that measures the colour quality of light in an interior, relative to the film type being used, and calculates any filtration necessary).

Colour compensation tables refer to appropriate colour compensation in terms of a numerical density or strength, followed by the initial of the colour of the particular filter, or filters, required for the situation. They frequently also give the exposure increase in terms of *f*-stops necessary for the recommended filtration. For example, the filtration needed to compensate the colour of light from a 'daylight-fluorescent' lamp for reproduction on a daylight-balanced film is recorded as 'CC 40M + 30Y, 1 stop'. This means that filtration with a strength of 40 Magenta plus 30 Yellow is required over the camera lens, with an overall increase in exposure of one stop.

These filters are especially useful to compensate for colour casts created by discharge lighting, i.e., non-incandescent light sources such as fluorescent, mercury vapour and metal halide lamps, which create light by means of an electrical discharge vaporizing a metal. The light produced may cover only narrow bands of the spectrum. However, the fluorescent coating on the inside of the glass tube of a fluorescent light expands the spectrum of light produced, enabling this type of non-incandescent lighting to be fully corrected in most cases. Colour compensating filters are also useful for correcting colour balance due to reciprocity failure of the film.

Unfiltered fluorescent lighting appears green on daylight-balanced film. To correct this, a magenta filter (known to some manufacturers as 'minusgreen') is placed in front of the lens. If further supplementary flash lighting is needed and is left unfiltered it would appear magenta on film as it has to pass through the compensating filter on the camera lens. To overcome this, green-coloured filters need to be placed in front of the flash units to convert their white light output to the equivalent colour balance of the fluorescent tube output. These can be purchased as large sheets of gelatin, cut to size, and then clipped to the flash unit.

Problems arise in situations of mixed lighting, when only a best possible compromise colour compensation can be achieved (see Chapter 7), and under sodium vapour lamps, which are discharge lamps that emit light of such a narrow yellow waveband it renders them uncorrectable. While critical colour compensation in situations of fluorescent

lighting requires the use of a specific combination of colour compensation filters for perfect results (see Table 7.1), there are readily available fluorescent compensating filters for either 'daylight-fluorescent' (FL-DAY) or 'white-fluorescent' (FL-W) which are adequate for most general uses, and when not in possession of a colour meter.

In summary, the basic colour correction filters (80A and 85B) are essential equipment for interior photographers working with film, and others in the series can be useful. With regard to colour compensation filters, the basic standard fluorescent filters are essential, while the full set of compensation filters of different densities are only necessary for critical work, when using a colour meter.

Filter mounts

Colour correction filters (and the standard fluorescent compensating filters) are available in two different forms: either they are circular in a fixed mount that screws into the front of the lens casing (such as those by B&W and Hoya); or they are square and slide into a filter holder to which different-sized adaptor rings are attached corresponding to the different diameters of the lens barrel (the Cokin and Lee systems being the best-known makes). Both types are excellent, the first type being the fastest to use and the latter type being both more flexible and cheaper. The square variety is the cheaper system because it is only necessary to buy one filter holder with the different-sized adaptor rings to suit your lenses, and the same filter is good for all sizes. (If the diameters of the lens barrels are of widely differing sizes, it may be necessary to buy two different sizes of filter holder to cope with this wide variation.) The other advantage of the filter holder is that it can also carry colour compensating filter mounts.

Tripod

The importance of a robust, sturdy tripod cannot be overstated. Interior photography inevitably necessitates long exposures – for which a heavy-duty professional tripod is essential. Both the changing of film backs and pulling out exposed sheets of instant-print film are substantial, jerky movements throughout which the camera must be held rock-steady to avoid even the slightest displacement from its critical position. Resetting a camera position if it has been displaced for any reason is a time-consuming and frustrating

Figure 4.7 A three-way adjustable tripod head (Manfrotto 160 view camera head, courtesy of Calumet) with quick-release mounting plate. The large handles enable fine and tight adjustments to be made in all three directions

business, as it involves rechecking all the settings, including the focus.

Professional tripods are made up of two parts: the head and the set of legs, both of which are bought as separate items to suit the purpose for which they are required. A good head and a good set of legs are each likely to cost a similar amount, so allow for this when making your choice.

Though usually a little more expensive, it is best to buy a black tripod as this eliminates the problem of its reflection in glass or other reflective surfaces in the picture. Other than being sturdy and black, check that the legs (including the central column) extend to a height at least as high as your eye level and preferably somewhat higher for extra flexibility. Screw tighteners, rather than clips, for locking the legs in position are also a sensible choice as they avoid any possibility of a clip snapping off. The legs should have rubber feet to prevent the possibility of any instability from slipping or sliding on a smooth floor.

With regard to the head, it is essential for it to be heavy and to have plenty of available movement in the three dimensions, with large hand-sized handles with which to make necessary fine and tight adjustments. It is also useful to have the movement in each direction calibrated in degrees of angle: by zeroing everything, the operation of roughly setting up the camera in the first instance is speeded up; and if different critical angles of a view need to be taken this calibration makes it possible.

Finally, a quick-release plate is another handy, time-saving device much to be recommended. It consists of a metal shoe that is screwed firmly into the base of the camera, and simply clicks in and out of the socket on the tripod head.

Necessary extras

As well as the actual photographic apparatus described in this chapter so far, there is one further bag of equipment that is extremely important to take on a shoot and should certainly not be overlooked. This is the bag of essential extras, including cable releases, flash-synchronization cables, extension cables, double/triple socket adaptors, continental socket adaptors (if working overseas) and spare fuses for both the flash units and the plugs. A screwdriver with which to fit the fuses is required, and also spare modelling lamps, spare batteries for the meters and, if enough room, a roll of masking tape which has endless uses, including taping cables to the floor to prevent people tripping in a busy area. A small dustpan brush can also prove invaluable for brushing the pile of a dark carpet (or one with a sheen) in a consistent direction, in order to eliminate the distracting and unsightly foot scuffs that such carpets attract.

Finally, try to keep each grouping of equipment in its own bag or case, so that each case can be checked off when leaving for the shoot in the knowledge that it is complete within. This also helps when packing up after the job – if every item has its own place within a specific case, a quick visual check can reassure you that you have not left anything behind.

5 APPROACH: COMPOSITION, STYLING AND LIGHTING

On arriving for an interior shoot, the first thing to do is to get a feel for the room or rooms to be photographed, and to make a mental note of the direction that the windows in each room face in order to calculate a shooting sequence that will make the best possible use of any available natural sunlight. A compass is useful for this purpose, bearing in mind that the sun rises in the east and sets in the west from a southerly direction (the degree of which varies with the time of year).

Having selected the interior in which you have chosen to start, find a position from which the camera can see the most significant elements of it, in a configuration that is likely to best convey the aesthetic concept of that interior. Often this position is in or near a corner of the room showing, most importantly, windows, at least two walls, and as much of the spatial qualities of the interior as possible.

Composition

The three main elements of composition are structure, line dynamics and perspective. Structure is concerned with organizing the different parts of the image into a harmonious whole within the borders of the film frame. Dynamic lines are those within the subject image that are juxtaposed at exaggerated angles for visual impact and are created by visualizing the image in a purely linear, two-dimensional, abstract way. Finally, perspective produces the illusion of depth on a two-dimensional surface, enabling the viewer to differentiate size and distance in the image.

Structure: symmetry

The simplest form of compositional structure is symmetry, whereby both sides of the image are identical, but opposite, around a vertical central axis. The simple, clean perfection of this type of composition is both its strength and its corresponding weakness. For example, the most exciting and aesthetically pleasing way of photographing either a grand Georgian entrance hall or modern commercial atrium of perfect symmetrical proportions might well be to photograph it from the precise central point as you enter the door. This would give the effect of showing the interior exactly as the architect would have intended, in all its symmetrical perfection, while creating a visually stunning shot in itself. However, symmetrical composition should only be used for exceptional interiors that truly demand such treatment. Unless appropriately chosen and executed with absolute technical precision, there is a tendency for symmetrical composition to appear dull and unimaginative. A flash of asymmetry within an otherwise perfectly symmetrical shot can often add an extra spark of interest.

Figure 5.1 The view through this Tudor doorway, and its central alignment with both the table and window, simply dictated the symmetrical treatment of this interior

Structure: Law of Thirds

We have seen that, to choose a symmetrical composition, the interior being photographed has to be outstanding in its own symmetrical perfection. The picture area, divided into two equal parts, is a fundamentally uninteresting arrangement – see Figure 5.2(a). A more interesting framework for composition is a division away from the centre, typically dividing the rectangle or square into a third and two-thirds, as shown in Figure 5.2(b).

(a) (b)

Figure 5.2 Drawing (a) shows a symmetrical division of the picture area around a vertical axis into two equal parts; while (b) shows a more interesting division away from the centre into a third and two-thirds

Taking this theory one step further, a frame divided symmetrically around both a vertical and horizontal axis produces a picture divided into four rectangles of equal size, as in Figure 5.3(a). Conversely, Figure 5.3(b) shows a frame divided into thirds around both a vertical and horizontal axis. This produces four rectangles all of different sizes, juxtaposed to create a much more interesting composition.

Thus, a composition with the main lines of the image constructed along the thirds, and any specific focal points placed at the intersection of a vertical third with a horizontal third, is likely to create an appealing shot. This is the principle behind what is commonly called the Law of Thirds, an approach to composition that universally appeals to our

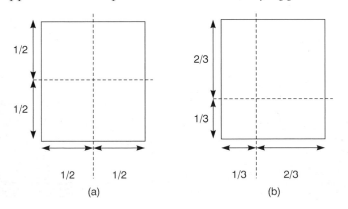

(a) (b)

Figure 5.3 Drawing (a) shows the picture area divided symmetrically around both a vertical and horizontal axis, producing a picture divided into four rectangles of equal size. Conversely, (b) shows the same area divided into thirds around both a vertical and horizontal axis, producing four rectangles all of different sizes, juxtaposed to create a much more interesting composition

Portrait Landscape Square

Figure 5.4 The division of three basic photographic formats according to the Law of Thirds

sense of beauty, and one which applies to all forms of picture making and therefore all branches of photography.

Having intersected the frame along the thirds, in both directions (see Figure 5.4) the Law of Thirds states:

(a) the main subject(s) should be positioned on or near an intersection of the thirds;

(b) some other element of the picture should lead the eye towards the main subject;

(c) the main subject should contrast with the background, either in tone or colour.

Figure 5.5 demonstrates two typical applications of the law in interior photography. Notice in the kitchen shot how the

Figure 5.5(a) The interior photograph of a kitchen has been intersected according to the Law of Thirds. Notice how the main focal points lie more-or-less on the intersection of the thirds: the window, the bowl on the work surface, the cooker and its hood. The positioning of the tea tray and bowl leads the eye in towards the corner of the kitchen

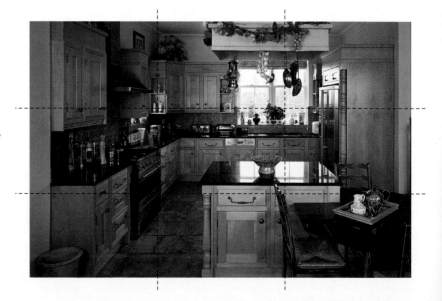

main focal points all lie more or less on the intersections of the thirds: the window, the bowl on the work surface, the cooker and its hood. The positioning of the tea tray and bowl leads the eye in towards the corner of the kitchen. Likewise, in the reception shot, the pillar is aligned with a vertical third and the desk is at the intersection of two thirds, with the shaft of sunlight leading the eye up the steps towards it.

The law does not have to be adhered to with strict precision. In fact, some of the most interesting shots often deviate from it quite dramatically and it is this deviation that can put a photographer's individual stamp on an image.

Figure 5.5(b) The reception area in this image also obeys the Law of Thirds with the main structural pillar roughly aligned with a vertical third, and the reception desk at the intersection of two thirds. The shaft of sunlight leads the eye up the steps towards the reception desk

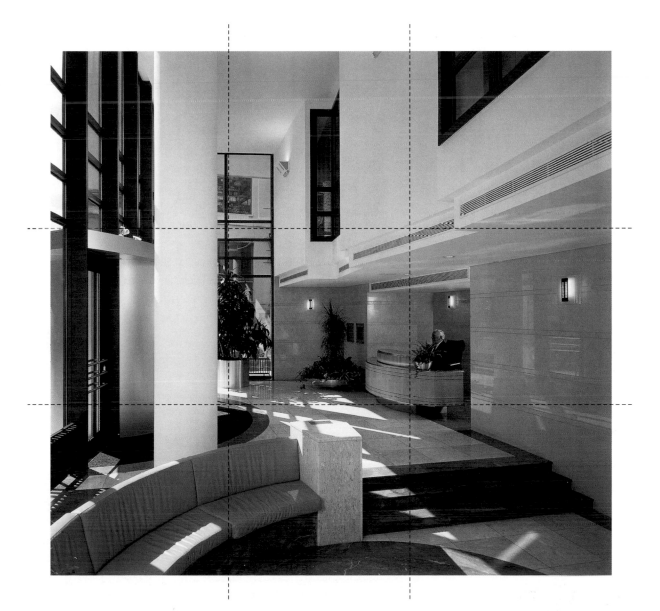

Whatever the deviation, however, the photographer should be aware of the law in order to understand how it can be successfully adjusted to his or her preferred individual approach.

Line dynamics

When a composition is viewed in a purely two-dimensional abstract linear way, those lines in the picture that are out of parallel with the edges of the frame are considered dynamic.

Figure 5.6 'Diagonals introduce powerful directional impulses, a dynamism which is the outcome of unresolved tendencies towards vertical and horizontal which are held in balanced suspension' (Maurice de Sausmarez)

The closer their angles are to 45° (i.e., half way between vertical and horizontal), and the more dramatic their juxtaposition at opposing angles, the greater the sense of excitement generated within the image, and therefore the more powerful its impact. The basic human significance of such visual dynamics is most eloquently described by Maurice de Sausmarez in his book *Basic Design: the dynamics of visual form* (1983):

> Horizontals and verticals operating together introduce the principle of balanced oppositions of tensions. The vertical expresses a force which is of primary significance – gravitational pull; the horizontal again contributes a primary sensation – a supporting flatness. The two together produce a deeply satisfying resolved feeling, perhaps because together they symbolize the human experience of absolute balance, of standing erect on level ground.
>
> Diagonals introduce powerful directional impulses, a dynamism which is the outcome of the unresolved tendencies towards vertical and horizontal which are held in balanced suspension.

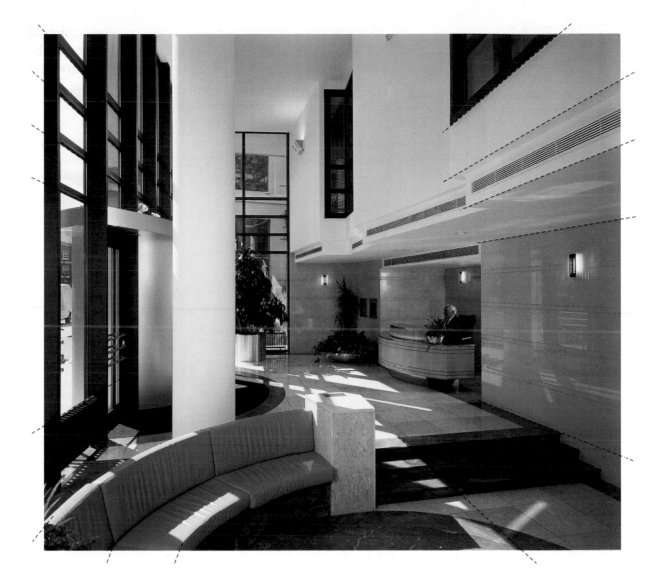

Remember also that the borders around the image exist as much to be broken as to contain the essential elements. The dynamics of the image are at their most powerful when the borders are broken at oblique angles, both by pieces of furniture and by the lines of perspective within the composition.

Figure 5.7 Notice the dynamic lines within the composition. The impact of an image is enhanced when its borders are broken at oblique angles by the lines

Perspective and spatial values

Line dynamics are the most significant mechanism in interior photography by which perspective produces the illusion of depth on a two-dimensional film surface. Lines converging to one or more vanishing points cause the subject to get smaller as it recedes into the distance.

When photographing an interior, the photographer usually wants to suggest the spatial value of the room as one element of his composition. To do this it is necessary to include more than one wall (either two or three) to give the viewer the illusion of depth. So long as the film back on the camera remains vertical, and is at an angle to the far wall of the interior, there will always be two principal vanishing points in the linear perspective of the image, often one inside the image area and one outside. This is what is known as two-point perspective. The dynamism of the lines can be exaggerated, the wider the angle of the lens used to include the same area of the interior in that image. Only when the film back of the camera is parallel with the far wall will there be only a single vanishing point, known as one-point perspective, with the lines of perspective converging within the area of the image itself. This is most successfully achieved with a cross shift movement on a view camera (see section on 'Shift movements' in Chapter 2).

In order to include two walls and show maximum floor area, the best camera position is usually in one corner looking towards the opposite corner. If three walls are to be included, the best place is often a third of the way along the length of the back wall, as shown in Figure 5.8, to avoid photographing the extra side wall at too oblique an angle.

Once the composition of the spatial area is basically established, the foreground composition has to be set, often with the dominant piece of furniture or decoration standing at the intersection of the thirds on the bottom horizontal. Further depth to the picture, and interest to the composition, can be

Figure 5.8 The different camera positions needed, depending on whether (a) two or (b) three walls are to be included in the image. In (b), the camera has been shifted a third of the way along the length of the back wall to avoid photographing the extra side wall at too oblique an angle

(a)

(b)

created by the addition of a piece of furniture in the immediate foreground, as with the sofa in our example (Figure 5.7), cutting across the bottom left corner of the frame.

Styling and detailing

Having selected the optimum camera position and established the basic composition for the photograph, it is time to turn your attention to the detail of the interior, and to style it if necessary to enhance its character, aesthetic appeal and interest. This is especially important for residential and office interiors, which are often massed with small details.

Styling is often a question of rearranging objects already in the room into a more aesthetic arrangement from the point of view of the camera angle and the composition. Styling mainly with objects already present should guarantee the harmonization of these objects within the established aesthetic concept of the room.

Different interiors demand different treatment: a rambling and cluttered country cottage interior will require a more casual approach than a formal stately home interior

Figure 5.9 Styling is often a question of rearranging objects already in the room into a more aesthetic arrangement from the point of view of the camera angle and the composition

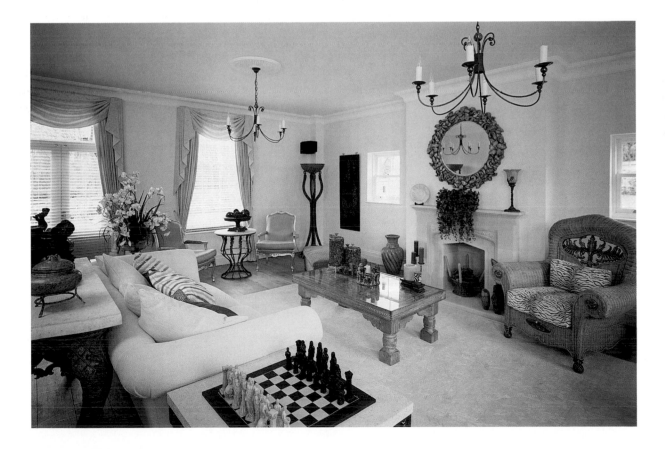

where detailing will often need to be precise, neat and tidy. The photographer, or stylist if one is employed, has to make a judgement of the atmosphere and character concept of the interior, and then exploit it to its best advantage. Appropriate flowers or fruit always add freshness and colour to the picture, giving the photograph added vitality. It would be appropriate to have wild flowers in an old jug in a cottage kitchen, but exotic lilies or perfect roses in a fine cut-glass vase in a stately home.

Unless specifically designed to be minimal or very formal, interiors are usually more interesting with plenty of detailing. A bare wooden table is never as interesting as a table laid for a sumptuous meal, or a sideboard covered with unusual trinkets and books which serve to fuel our understanding of the interior and the lifestyle of the people who have created it as their living space.

The styling and detailing should also tell a convincing story both to make the interior more inviting and, again, to increase our understanding of it. It should draw us in, invite us for a meal or cup of coffee, and make us feel comfortable and 'at home' once we get there.

In a dining room or kitchen, have the table laid for a meal or with succulent food mid-preparation, or have a few tastefully arranged remains of a meal with a chair pulled out from the table and angled towards the viewer. Avoid unsightly packaging and brand names: go for the wholesome approach. In the living room or study, have a few books or magazines casually arranged on the coffee table, chair or desk, and leave one open under a lamp with an open pair of glasses on it to suggest that someone has just left their chair briefly. In a bedroom, leave a dressing gown casually strewn (yet carefully arranged) across a corner of the bed; and in the bathroom, throw a towel over the edge of the bath. In an office interior, have the corner of a financial paper draping down the side of a desk and business papers in a none too tidy pile. Maybe an open fountain pen on a half-written pad of paper.

These are just suggestions to try and create a feeling for the approach to styling. Involve yourself with the room and work within it, as part of it, in order to discover the appropriate styling required. Only a fine line exists between being bold and highly individual with your styling of interiors and being inappropriately outrageous to the point of ridicule. True creativity is knowing how to ride this delicate line between unacceptability on the one side and unoriginal

mediocrity on the other. As with composition, it is the point at which you start to break or stretch the rules that can produce the most creative styling. And again, this is where individual interpretation has its freedom of expression, which is why no two photographers will ever take exactly the same interior photograph of the same room.

Lighting

All interiors have their own individual combination of 'available' light sources by which the naked eye views them. This is often a mixture of daylight through the windows, with some form of artificial lighting to supplement it: a ceiling light or table lamps, for example. This available light, especially the daylight, creates mood and atmosphere in the room, and it is this that we want to convey in our image.

However, the contrast between the light and shade areas in an interior, though readily discernible to the eye, is usually too great to record on film: the light areas tend to 'burn out' and the shadow areas become a black void. The reason for this is that while the eye is sensitive to a range of at least 10 stops, colour transparency film only records about a 5 stop range, and colour negative film a 7 stop range.

In order to reduce the contrast, and thereby enable us to record the image clearly on film, we have to supplement the existing light with photographic lighting. This is a very subtle process, as we want to preserve the atmosphere and interplay of light and shade in the room, while reducing the contrast to acceptable photographic levels.

'Fill-in' lighting

Extra photographic lighting added by the photographer must be of a 'fill-in' nature, allowing the available light to remain the dominant source of illumination, except where special effects are required. This fill-in light, because of its secondary though important role, should be a diffuse light source, typically a flash bounced off a white umbrella or white wall, or a flash fired through a soft-box. Such diffuse lighting is the most subtle way of inconspicuously reducing the contrast of the available light.

The strength of this fill-in light should be approximately one-quarter the power of the dominant light source. In other words, the general ambient light reading in the interior should be 2 stops greater than the flash reading taken at a similar place.

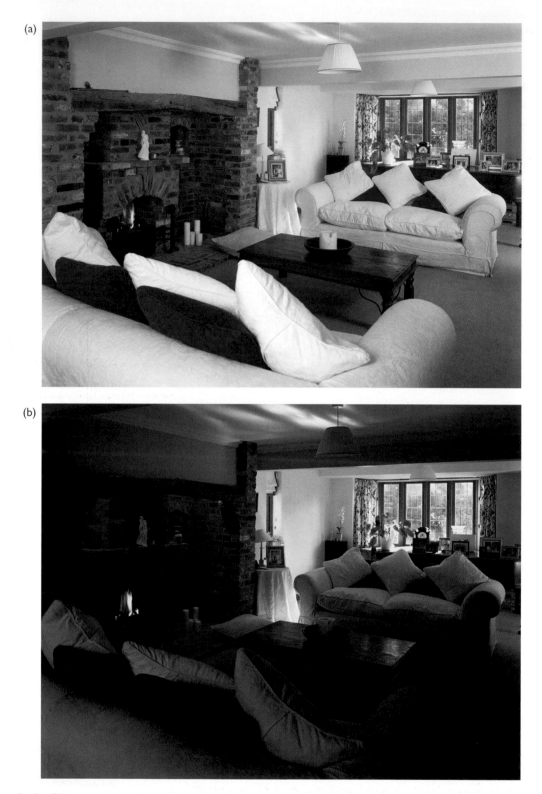

Figure 5.10 Fill-in lighting. In image (a), the interior appears as the eye sees it. Because the sensitivity of the eye is much greater than the sensitivity of film, fill-in flash lighting has been added to reduce the contrast to recordable levels. Image (b) was taken without supplementary lighting, to illustrate the point

Placement of lights

The precise angle of this fill-in light is not critical because of its diffuse and subordinate nature. However, placed at an angle between the camera and the dominant light source (often a window), the gradual transition from light to shade is maintained, but the contrast subtly reduced. An angle closer to the camera, or even on the opposite side of the camera to the dominant light source, is usually acceptable, though tends to diminish the effect of atmospheric transition from light to shade.

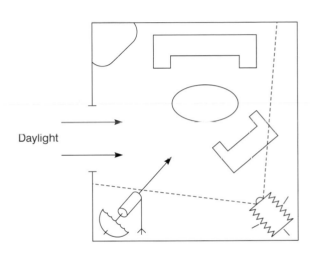

Daylight

Figure 5.11 The placement of photographic lights for the fill-in effect. The best place is at an angle between the camera and the light source (often a window). This maintains the gradual transition from light to shade, while subtly reducing the contrast to recordable levels

A fill-in light on the opposite side of the camera also runs the risk of creating its own conflicting set of shadows, thereby reducing its subtlety. A well-lit interior should give the viewer the impression that no extra photographic lighting has been used at all.

Different requirements for different clients

The precise approach that a photographer adopts to shoot a particular interior assignment will depend first on the use for which the photographs are being taken, and second on the dictates of the client's preferred style.

For example, a property agent is likely to expect bright, clear, evenly lit images, with perhaps stronger than usual fill-in lighting. He will probably prefer you to shoot with your widest available lens (without linear distortion) to maximize the illusion of space in the room, and to include as many windows in view as possible to create the impression of a property with plenty of natural daylight.

An architect, on the other hand, is more likely to be interested in symbolic shots showing the aesthetic and functional style of a particular building and its interior. While a wide shot will inevitably be part of the brief, the wide-angle lens is used more to exaggerate a specific aspect of the interior than to emphasize floorspace.

Editorial clients also have different preferences. For example, while they like to emphasize the atmosphere of an interior, created by available light, they differ in opinion over whether room lights should be left on or off. Some interior magazines believe that room lights and lamps should never be switched on, the philosophy being that one only turns on the lights on grey or rainy days. They also aim to shoot most of their features in the summer months since they are not in the business of selling dull days to their readers. Other magazines, on the other hand, which specialize in interior-designed rooms, do often like to have the lamps switched on in order to show off the lampshade designs to their best advantage. Some magazines prefer the use of a standard lens where possible rather than a wide angle, in order to create a more intimate and natural perspective, similar to the eye view of an interior.

A knowledge of the preferences and priorities of your clients is, therefore, essential. When starting work with new clients, it is always worth inspecting their recent publications to gain the best possible understanding of the way they like to work.

Detail shots and continuity

Alongside general interior shots, a client is likely to demand detail photographs as close-up extras to boost the illustrative impact of a set of pictures. These can range from decorative detail shots for a magazine feature of elaborate pieces of furniture, as styled for the main shots, to detail shots of cornicing or door handles to enhance the feel of quality in a property brochure. Modern light fittings or abstract construction detail may be the demand of an architect. Such details are important extra shots and should always be considered when working out your overall shooting sequence. Furthermore, it is sensible to decide at this stage which images are to be shot landscape and which portrait. A mix of each will give the editor and designer a wider scope for layout, and will enhance the visual interest of the printed page.

(a)

Figure 5.12 Detail shots boost the illustrative impact of a set of images. The sleek wall-lights and exotic flowers in (a) convey a sense of quality, whilst a detail shot of a decorative ceiling in (b) can be used as a faint textured background for a brochure

(b)

When several shots are taken of the same interior from different angles, including detail photographs, great care must be taken to ensure a natural continuity between them, both of lighting and styling. The same lighting ratios between available light and flash must be maintained throughout to retain the same atmospheric appearance of the room.

It also helps in a set of photographs of an interior to show continuity between the shots in terms of furniture in view. In other words, it is best if possible to have one or two pieces of furniture or obvious features that appear in several of the shots, from different angles and perspectives, to act as mental reference points for the viewer.

6 TECHNIQUE IN PRACTICE

This chapter is about the actual mechanics of taking the photograph in order to achieve the best possible image, be it on film or digital. The practice for each is similar and most of the information in this chapter is appropriate to both technologies. When shooting film, most interior images are shot on a daylight-balanced colour transparency material, typically ISO 100, as this requires no filtration where daylight is dominant and the fill-in is from a flash source. Traditionally, a slow tungsten-balanced colour transparency film was the specialist film for interior photography as it is specifically designed for long exposures up to 100 seconds without any need for filter correction as a result of reciprocity failure. However, improved technology of the daylight-balanced colour transparency films means that similar exposures can now be made without any significant reciprocity failure, which is sufficient for most interior requirements. The majority of this chapter will therefore assume the use of a medium speed, daylight-balanced transparency film, though the use of tungsten-balanced film will be discussed in a separate section at the end of the chapter.

Lens selection

Having chosen the best position from which to take the photograph, select the appropriate lens for the job. This is likely to be a wide-angle lens, often the widest angle available because of the usual restrictions of space (not being able to get back far enough). It also gives the best depth of field and maximizes the illusion of space in a room by exaggerating the perspective.

This exaggeration of perspective must, however, be used judiciously as, in photographic terms, it is a form of

Figure 6.1 Geometric distortion. The closer an object is to a wide-angle lens, and the further it is from the central optical axis of that lens, the greater the geometric distortion of that object. Consequently, the plates in the foreground of this picture appear as ovals sliding out of the composition. This effect has been further exaggerated by the use of a vertical shift movement

distortion. The closer an object is to a wide-angle lens, and the further it is from the central optical axis of that lens, the greater the visual distortion and unnatural appearance of that object. For example, round plates in a bottom corner of the frame, photographed on a foreground table, can become awkward ovals sliding out of the composition. This can be further exaggerated by excessive shift movements, as any shift movement is a shift away from the central optical axis of the lens.

All wide-angle interior photography, therefore, is a compromise between coverage and distortion, though the effect of this distortion can be gainfully employed if the maximum illusion of space is demanded and due care is taken. Otherwise, a rule of thumb for lens selection is to select the longest focal length lens capable of including all the

significant elements of the interior. If it is a feature or small part of the interior that you wish to photograph, a standard lens or a short telephoto may be more appropriate. The advantage of the standard lens is that it has approximately the same focal length as the human eye, thereby giving the perspective in the image a high degree of normality. The telephoto, on the other hand, can be effectively used with a wide aperture to render sharp the feature while blurring the background.

Mount the camera on the tripod in the perfect position and get it roughly focused so that you have a clear idea of the picture you intend to take. Check with a spirit-level that the film plane is perfectly vertical to avoid any converging or diverging of the verticals in the image. If you need to include more of the floor or ceiling in the picture while retaining perfect verticals, you can do one of two things. You can either lower or raise the height of the camera on the tripod or, if using a view camera, you can raise or lower the front or back standard, which has the added advantage of also maintaining the level of the viewpoint already selected.

Lighting

Next, consider the lighting in terms of what is available, how you choose to supplement it and the effect you wish to create. Assuming you decide that the daylight through the windows is to be the dominant light source, you then have to decide whether or not you want any of the artificial room lights or table lamps switched on. These can add warmth to the picture and can brighten otherwise dimly lit corners, but they can also diminish the subtle atmosphere of an interior that appears to be lit only by daylight. Different combinations are appropriate for different purposes, as discussed at the end of the previous chapter, and again it comes down both to personal preference and the specific use of the photographs.

Having made your decision, you must next set up one or more flash units (depending on the size of the interior) to act as the fill-in light to reduce the overall contrast in the photograph. Fill-in flash is at its most subtle when bounced in from the side, at a place between the camera and the window, thereby supplementing the direction of the daylight from the window and maintaining the gradual transition from light to shade, while reducing the contrast to recordable levels. However, this is not always possible because of flash reflections appearing in the image. When this is the case, a

Figure 6.2 The effect of flash bounced off a white umbrella is similar to that bounced off the apex of a white wall and ceiling. This is a useful way to light an interior when space is restricted, and it also avoids the problem of unsightly umbrella reflections

position closer to the camera or even on the other side of the camera is still acceptable so long as the lighting ratio is significantly in favour of the dominant daylight.

If you are cramped in a corner, set up the flash unit beside the camera. If space allows, either bounce the flash off a white umbrella, or fire it through a soft-box if preferred. Alternatively, if space is very restricted, you can bounce the flash off the top apex of the wall behind you if the wall is white (any other colour will create a colour cast in the fill-in). Keep the height of the flash unit above the height of the camera so that the fill-in flash bounces slightly downwards onto the scene, at a similar angle to daylight through a window. Try and avoid placing the flash unit too close to any individual piece of furniture. This will allow the fill-in to penetrate as far into the room as possible, without 'burning out' any piece of furniture in the foreground.

With the flash unit(s) in place, make any necessary styling adjustments and check the image in the viewfinder. Look out for unwanted flash reflections and adjust the position of the flash units, camera, or both as required.

Focusing

Next turn your attention to final focusing. To ensure absolutely perfect focus throughout the image area, one has to calculate the optimum plane of focus and necessary aperture for the required depth of field, but this is something we will come to later in the chapter, in the section on 'The use of tungsten-balanced film'. More simply, for the purposes of this quicker alternative, most SLR roll film camera lenses have depth of field scales engraved on them which give a reasonably accurate guide as to the available depth of focus for any particular aperture. A simple rule of thumb technique (so long as your aperture will be a minimum of 2–3 stops smaller than its widest) is to focus at a point half-way between the mid-foreground and the far wall. This should guarantee that the far wall is in focus and gives you a good chance that close foreground objects will be in focus as well. Check it visually by looking through the viewfinder with the lens stopped down, though this is sometimes difficult because of low levels of available light. If there is any doubt, it is usually better to ensure that the background is in focus rather than the foreground, as this tends to be more visually acceptable.

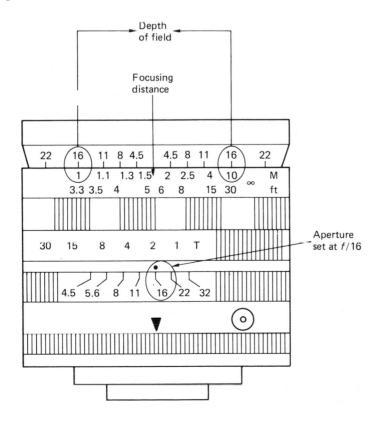

Figure 6.3 The depth of field scale on a roll film SLR camera lens. The aperture markings show the limits to the depth of field for any particular aperture, when compared with the distance markings. In this example, on a 50 mm medium-format wide-angle lens at *f*/16, the image would be sharp between 1 m and 10 m when focused at 1.7 m

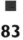

Flash/light metering

One or two 500 J flash units are adequate as a fill-in for most residential interiors when using ISO 100 film, though for large interiors more units may be necessary. There are two ways to proceed. First, the traditional way is to meter the ambient light and work out a desirable aperture and exposure combination (within tolerant limits of both flash output and film sensitivity). You then adjust the flash output to register a meter reading a stop or two wider (see next section) depending upon the strength of fill-in lighting that you want.

Daylight

Figure 6.4 The placement of photographic lights in a large interior for effective fill-in lighting

Alternatively, a simpler but less orthodox approach is to allow the maximum output of the bounced flash to dictate the aperture setting on the camera. Take an incident flash reading from a point approximately one-third of the distance between the flash and the farthest wall, or off the first piece of furniture in the picture that is in its line of fire if that is closer. Assuming a typical reading of, for example, f/11 at ISO 100 from the flash output, you use this as your working guide. Next turn off the modelling lamps on the flash units. Then, using your light meter, take several exposure readings for an f/11 aperture setting. Take these as either direct readings off the floor, walls and furniture (or off a grey card) around the middle of the room, or as incident readings from

similar places. Avoid directing the meter at the windows as their intense brightness will cause misleading readings. Determine a mean, compromise exposure for the general available light level in the room. This could, for example, be $\frac{1}{4}$ second at our predetermined $f/11$ aperture.

Evaluation of lighting ratio variants

A $\frac{1}{4}$ second exposure at $f/11$ would give us an even balance of flash and available light, thereby creating a flat and uninteresting, uniformly lit image. To increase the effect of the daylight at the expense of the flash in order to create a more interesting, atmospheric and natural look in the image, it is necessary to increase the exposure time and correspondingly reduce the size of the aperture. A change of 1 stop each way would double the exposure from $\frac{1}{4}$ second to $\frac{1}{2}$ second, and halve the aperture from $f/11$ to $f/16$. This would have no effect on the quantity of available light received on the film, but would effectively halve the impact of the flash. The flash reading would still be $f/11$ as, due to the very short duration of the flash discharge (around 1/500 second), it is not affected by changes in these longer exposure times. A change of 2 stops each way would mean a 1-second exposure at $f/22$, thereby having the effect of reducing the flash output to one-quarter the power of the available light, which is the preferred power ratio of fill-in to dominant light sources. I suggest you use this ratio as your starting point for shooting the first instant-print to assess the actual effect of the mixed lighting in terms of intended results, and as a base for bracketing exposures on the film when you are happy with the instant-print image.

Instant-print assessment

The first instant-print test shot (on ISO 100 daylight-balanced film) should give a clear indication as to whether the image is more or less as you intended. If it is perfect, you can proceed with shooting the actual film. If, however, the instant-print is too dark, too light or the mixture of lighting is unsatisfactory, make the necessary exposure and aperture adjustments that you feel will correct this and then shoot a further test shot. Shooting a second instant-print on a slightly different camera setting will also give you a clearer understanding of the actual effect that a $\frac{1}{2}$ or 1 stop difference can make, thereby giving you a better idea of the extent to which further adjustments might change the image. The instant-print is an invaluable tool for

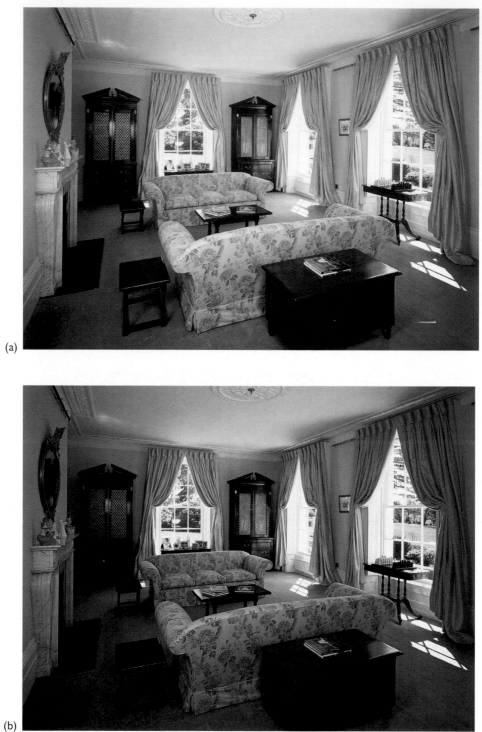

(a)

(b)

Figure 6.5 Evaluation of lighting ratio variants. Four colour transparencies show different ratios of flash output to the strength of the available daylight. Photograph (a) shows an even balance of flash and available light: $\frac{1}{4}$ second at $f/11$. The interior appears uniformly lit, producing a flat image. In (b), the effect of the daylight has been increased at the expense of the flash by 1 stop each way: $\frac{1}{2}$ second at $f/16$.

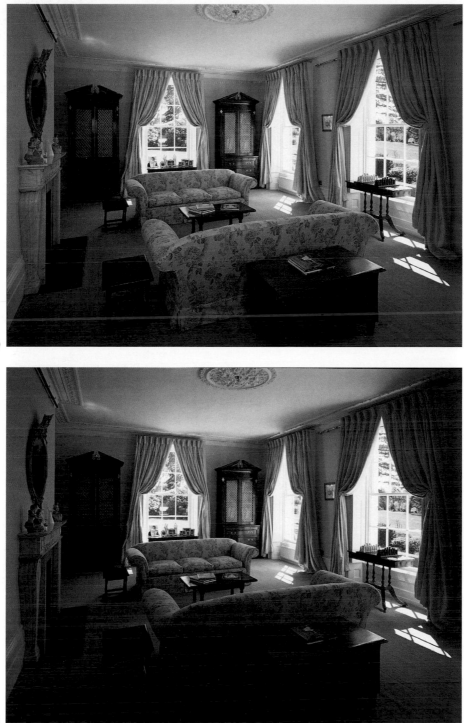

(c)

(d)

Figure 6.5 Photograph (c) shows the effect of a 2 stop difference each way, whereby the flash output is now one-quarter the power of the available daylight: 1 second at $f/22$. This is often the preferred power ratio of fill-in to dominant light. For the purposes of exposure comparison, (d) was taken with just daylight and no supplementary flash at all: 1 second at $f/22$. Notice how the exposure for the daylight has been kept consistent throughout. Subtle fill-in lighting creates a natural atmospheric balance on film between even, flat lighting, and excessive contrast when using available light alone

getting your image near perfect before committing it to the real film, but it is a poor guide to both colour and focus (it is too soft to show up sharp detailing on medium format). However, if you are happy with the instant-print image, you will be delighted with the image on transparency.

Exposure trials

Suggested exposure trials for this example:

	Exposure	Aperture
Original meter reading	$\frac{1}{4}$ second	f/11 (flash reading)
Starting point: 2 stop each way differentiation	1 second	f/22 (× 2 frames)
Further trials/brackets	1 second $\frac{1}{2}$ second 2 second	f/19 – f/27 f/13 – f/16 – f/19 f/22 – f/27 – f/32

I suggest shooting two frames of the likely perfect exposure, with $\frac{1}{2}$ stop aperture and exposure variations around this base.

These ten exposure trials will fill a roll of film on a 6 cm × 7 cm format, or will leave you with two spare frames for further trials on the square 6 cm × 6 cm format. You will find that most of the frames will be usable, but that they vary both in brightness and ratio of available light to flash. This gives the photographer and client a wide choice of slight variations in the final photograph, a choice that will be dictated both by usage and personal preference. It also demonstrates the advantage of flexibility that roll film holds over sheet film.

Apart from giving a more natural appearance to the room's illumination, another positive result of increasing exposure time and reducing the aperture size is that it progressively increases the depth of field to a point whereby everything in shot is likely to be in focus when stopped down for taking the actual photograph.

The use of tungsten-balanced film

Tungsten-balanced colour transparency film can be useful for photographing large interiors, such as theatres for example, which are well lit with ambient tungsten lighting and require

Figure 6.6 The use of tungsten-balanced film. For interiors illuminated with tungsten lighting, this is the ideal film choice. It is especially useful for narrow interiors such as this where there is no room to place any photographic lights

little, if any, extra photographic lighting. It is also suitable for photographing tungsten-lit corridors, where extra photographic lighting can be awkward or impossible to place, giving perfect colour correction to the ambient lighting – see Figure 6.6.

The special property of tungsten-balanced transparency film rated at ISO 64 is that it has been specifically designed for long exposures between 1/10 second and 100 seconds without suffering any significant reciprocity failure. At 100 seconds, Kodak suggests its Ektachrome 64T film requires merely a $\frac{1}{3}$ stop exposure increase and no filter correction. Such tolerance to long exposures therefore makes this the ideal film choice when small apertures are required to achieve maximum depth of field in the image of a deep interior, such as a church, for example (this was the film chosen for the 'Painting with light' technique in Chapter 8). The long exposure times also give the photographer enough time to fire the flash units several times to build up sufficient fill-in light for such small apertures. For most interior work where daylight is the dominant light source, an 85B colour correction filter is necessary over the camera lens. However, the density of this filter reduces the effective film speed by 1 stop to ISO 32.

Deducing the optimum plane of focus

The theory behind perfect focus throughout the depth of the image being photographed is to establish the optimum plane of focus from which sharpness will extend in both directions to include the nearest and furthest elements of the picture, at a certain aperture. It is also important to find the largest aperture possible that will encompass this zone of sharpness as the performance of even the best lenses tends to fall off at apertures smaller than $f/22$. Using the largest aperture possible has the further advantage of minimizing the necessary flash output and exposure time.

The simplest way to do this is to measure the bellows displacement between the focus on the furthest and nearest elements of the image, and then set the camera to half the displacement measured. So first focus the camera on the furthest element (the far wall in an interior) and mark this position at the monorail, baseboard or focusing knob. Then focus on the nearest element. The camera focus will increase and a second focus setting will be obtained. Measure the

distance between the two displacements and set the camera at half this measured displacement. The optimum focus position for the desired depth of field zone has now been established. The corresponding working aperture needed to cover the required depth of field is found in the 'Linhof universal depth of field table'. The appropriate minimum *f*-numbers for a given film format are listed for various bellows displacements.

Universal depth of field table

Table 6.1 shows different displacements at the same aperture for different formats because smaller negatives normally require a higher magnification. As a result, closer tolerances apply for calculating the depth of field available for critical sharpness.

If neither the smallest possible aperture nor a Scheimpflug adjustment can produce sufficient depth of field to

Table 6.1 The 'Linhof universal depth of field table' calculates the minimum aperture needed to cover the required depth of field, once the optimum focus position has been established

Linhof Universal Depth of Field Table

Focus camera to far and near object points (also when Scheimpflug rule is applied) and measure extension difference in mm, using scale above. Look up this figure in appropriate format column and read off f/stop required to obtain the necessary depth-of-field on the same line at right. For intermediate values, use next smaller f/stop shown on the line below.

Set rear standard at half the displacement established

	2¼×2¾ in.	4 × 5 in.	5 × 7 in.	8 × 10 in.	f – stop
mm	1,2	1,6	2,4	3,2	8
mm	1,7	2,2	3,3	4,4	11
mm	2,4	3,2	4,8	6,4	16
mm	3,3	4,4	6,7	9,0	22
mm	4,8	6,4	9,6	12,8	32
mm	6,7	9,0	13,5	18,0	45
mm	9,6	12,8	19,2	25,6	64
mm	13,5	18,0	27,0	36,0	90
mm	19,2	25,6	38,5	51,2	125
mm	27,0	36,0	54,0	72,0	180
mm	38,5	51,2	77,0	102	250

In close-up work, the f-stop taken from the table should be corrected as follows
G = 6f : open by ½ stop; G = 2f : open by 2 stops;
G = 4f : open by ⅔ stop; G = 1.5f : open by 3 stops;
G = 3f : open by 1 stop; G = 1.3f : open by 4 stops;

Explanation: G = distance of diaphragm plane to the forward ⅓ of the subject; 6f = 6 × focal length of the lens employed.

render the full depth of the image sharp, a smaller reproduction ratio has to be chosen by increasing the camera-to-subject distance or using a lens of shorter focal length.

Universal depth of field calculators

Universal depth of field calculators are available for some view cameras. These work on exactly the same principle as described above and are more convenient as they are built into the camera and remove the need for any further external tables. They consist of a movable aperture scale on the rear focus knob which indicates the working aperture for any required depth of field, and also the optimum focus position.

Multiple flash and multiple exposure

Once perfect focus has been achieved, and the working aperture deduced, it is time to take a light reading of the available light to determine the exposure required for the working aperture. Let us assume that the working aperture was calculated as $f/22$, and the exposure required measured as 8 seconds at ISO 32 (that is, ISO 64 less 1 stop for the colour correction filter). If the flash reading is $f/5.6$ at this film speed, the flash output needs to be boosted to read $f/11$ for it to act as an adequate fill-in, 2 stops below the available light reading of $f/22$. To do this, one would have to fire the flash unit(s) four times during the 8-second exposure: once for $f/5.6$; twice (double the output) to boost it 1 stop to $f/8$; and then double that output making a total of four times, to boost it a further stop to $f/11$. This is done most easily by firing the flash units manually with the flash meter, so long as the length of exposure allows for the number of flashes needed. Otherwise, it should be done by multiple exposure: in this case, for example, four 2-second exposures with the flash unit(s) fired each time directly by the camera. A Prontor Professional self-cocking shutter system on a view camera lens is the perfect shutter system for multiple exposures as it prevents any small movement of the camera between exposures as a result of re-cocking the shutter.

Having determined the optimum aperture and exposure, and calculated the necessary flash output, it is time to shoot an instant-print test shot to check that your calculations are

creating your intended results. If using ISO 64 tungsten-balanced instant-print film, expose it just as you would for the transparency film, but with any slight exposure adjustments recommended on the pack to take account of the ambient temperature. If you are choosing to work with ISO 100 daylight-balanced instant-print film, remove the 85B filter for the test shot and follow the calculations outlined below.

Exposure calculations between instant-print and transparency films of different speeds

Remember that our calculations are based on a film speed of ISO 32, whereas the daylight-balanced instant-print film is rated at ISO 100. If we keep the working aperture constant at f/22, the exposure time and flash output will need to be adjusted accordingly. The difference in film speed between ISO 32 and ISO 100 is almost exactly $1\frac{1}{2}$ stops (1 stop: 32 + 32 = ISO 64; $1\frac{1}{2}$ stops: 64 + 32 = ISO 96; 2 stops: 64 + 64 = ISO 128). Because the instant-print is the 'faster', more light-sensitive film, because of its higher film speed rating, the exposure time and flash output will have to be decreased by $1\frac{1}{2}$ stops for the purposes of the test shot(s).

Thus, a $1\frac{1}{2}$ stop decrease in an 8-second exposure would be a 5-second decrease, creating a 3-second exposure for the instant-print shot (1 stop decrease: 8/2 = 4-second decrease; a further $\frac{1}{2}$ stop decrease on remaining 4-second exposure: 4/4 = 1-second further decrease, making a total decrease of 5 seconds).

A $1\frac{1}{2}$ stop decrease in a four-flash output would be a $2\frac{1}{2}$ flash decrease, creating a $1\frac{1}{2}$ flash output for the instant-print shot (1 stop decrease: 4/2 = 2 flash decrease; a further $\frac{1}{2}$ stop decrease on remaining 2 flash output: 2/4 = $\frac{1}{2}$ flash further decrease, making a total decrease of $2\frac{1}{2}$ flashes.

So, the ISO 100 instant-print is shot at f/22 with a 3-second exposure, and $1\frac{1}{2}$ flashes at full output (a little awkward, but quite possible for the purposes of the instant-print). Assuming you are happy with the result of this instant-print, you can now put the 85B colour correction filter on the lens and proceed to shoot the transparency film. Bracketing is the best way to guarantee a perfect result, so below are the bracketing suggestions for this particular example, again assuming a 10-frame roll film.

Exposure/flash trials

Suggested exposure/flash trials for this example:

Aperture constant at *f*/22

	Exposure	No. of flashes
Starting point	8 second	4 (*f*/11) (× 2 frames)
Further brackets	8 second	2 (*f*/8)
	8 second	6 (*f*/13)
	8 second	8 (*f*/16)
	8 second	12 (*f*/19)
	4 second	8 (*f*/16)
	6 second	4 (*f*/11)
	12 second	4 (*f*/11)
	6 second	8 (*f*/16)

Again, this allows two frames for the likely perfect exposure, and $\frac{1}{2}$ stop variations in exposure time and flash output around this base. While most frames should be usable, they will vary in terms of both brightness and ratio of the dominant available light to the fill-in flash. This gives the photographer and client a full choice for final reproduction, depending on usage and personal preference. Notice that the working aperture remains constant throughout at *f*/22, as this was the determined maximum aperture for perfect focus throughout the depth of the image, thus giving both perfect focus and optimum lens performance for the situation.

If the instant-print test shot is either too dark or too light, or the balance of dominant to fill-in light is not to your liking, then assess the necessary exposure and/or flash adjustments and shoot further test shots until you are completely satisfied with the result. A satisfactory instant-print should yield an excellent result on transparency. If working with ISO 100 daylight-balanced instant-print film, do not forget to increase the exposure time and flash output by $1\frac{1}{2}$ stops to deduce the starting point for bracketing on the transparency film, and again remember to put the 85B filter over the lens.

Checking colour balance

Finally, the colour balance of the artificial light source(s) may need to be checked to ensure optimum colour rendition on the final transparency. This is done by using a colour meter, which measures the colour balance of light in an interior and then calculates the colour correction and compensating filters

necessary to balance the light to the film being used. You register the film type into the meter, and then take an incident reading from the centre of the room. The relative responses of the three colour-sensitive photocells to this light are compared, displaying a readout of any necessary filtration required. It is important to use as few filters as possible to retain optimum image quality.

Checking the colour balance of the available light in an interior is essential for critical colour rendition in situations of only artificial lighting – for example, tungsten and/or fluorescent. Where daylight is present in an interior, and especially if a window is in view, you must remember that any filtration you put over the lens to compensate for the colour casts of the artificial lighting will also discolour the daylight on the recorded image. For details on how to overcome such problems, see Chapter 7.

Checking the colour balance is only of limited use for residential interiors where daylight is likely to be dominant. It is usually more important to maintain the same balance of available tungsten lighting to daylight between shots of the same room in order to retain the same atmosphere than it is to ensure perfect colour reproduction. A reddish glow from a table lamp, for example, can create a desirable warmth in the picture adding to the rich essence of the interior. Personal preference and the use for which the photographs are being taken should guide you in these matters.

Professional etiquette

As a conclusion to this chapter on the fundamental techniques of interior photography, it seems appropriate briefly to outline some guidelines on professional etiquette that all interior photographers should follow. This is important, both as a matter of natural courtesy to the client and/or owner of the property being photographed and also to demonstrate an attentive respect to create the best possible impression to further your chances of future commissions.

These guidelines include being polite and respectful of the owner's property on a shoot – which could be the personal and private sanctuary of the owner's home – and to always carefully rearrange every photographed interior back to its original state. If possible, remember to bring an old plastic carrier-bag with you in which to collect and take away your rubbish. Film papers and boxes, instant-print papers and empty packs are messy and quickly mount up.

7 INTERIORS WITH MIXED LIGHTING

The last chapter, on technique, dealt with an average interior illuminated predominantly by daylight, with supplementary fill-in flash. Any artificial room lights or lamps have been treated as either negligible or atmospheric. Interiors illuminated predominantly by artificial lighting are, however, likely to appear with an unacceptable colour cast on a film balanced for white daylight, if no filtration is used over the camera lens: tungsten lighting will produce an orange cast and fluorescent an unpleasant green one. Likewise, if tungsten-balanced film was used in an interior of predominantly tungsten lighting, any daylight or flash would produce a cold blue cast on the film. None of this applies to digital photography, of course, where the white balance can be set at the time of exposure, and colour balance adjusted in post-production.

For optimum colour rendition in interiors with mixed lighting, the 'multiple exposure' technique is the best method, whereby a separate exposure with appropriate filtration is made for each different light source independently, all on a single film frame. It is essential to keep the camera absolutely steady throughout the whole process as even the slightest movement between exposures can cause a double image on the film.

Mixed daylight and tungsten

Most residential interiors, and some offices, are illuminated by a combination of daylight and tungsten lighting in the form of ceiling lights or table lamps. This can present a problem, as discussed above: no filtration would create an orange colour cast on daylight-balanced film, while filtering

specifically for the tungsten lighting would cause the colour of the white daylight to appear blue on film. There are several alternative methods for dealing with such situations of mixed lighting, depending on the effect being sought.

The first, the simplest, and often the best method is to leave all the tungsten lamps switched off, and work with just the dominant daylight and flash: a technique that is preferred by most of the interior magazines. Alternatively, if the

Figure 7.1 Mixed flash and tungsten. A double exposure was used on daylight-balanced film. The first part of the exposure was for the flash alone (located beside the camera) at a fast shutter speed, without filtration, and the second part was for the ambient tungsten lighting with an 80A filter over the camera lens

tungsten lamps are to appear lit in the photograph, you can either replace the bulbs with special colour-corrected 'daylight' bulbs, or switch them off for a portion of the exposure and correspondingly increase the exposure for the daylight to reduce their impact. These are the methods used by most interior photographers most of the time, tungsten lighting being considered an acceptable warm light source (as opposed to the sickly green of fluorescent).

It is, however, possible to use a multiple exposure to improve the overall colour rendition on the transparency. As a general rule for any mixed lighting situation, the total exposure of a single film frame can be divided into as many parts as there are different types of light source in the interior to be photographed, assuming that each different source can be controlled independently of the others. To control the daylight, it will have to be possible to black out the windows. You divide the exposure in two: the first part for the daylight and any fill-in flash, with the tungsten lights switched off; and the second part for the tungsten lights only, with the windows blacked out. Using tungsten-balanced film, the first part of the exposure for the daylight and flash would have to be filtered with an amber 85B colour correction filter. The exposure time for that part of the overall exposure, and also the flash output, would have to be increased by 1 stop to take account of the strength of filtration.

A light meter reading should be taken with full available light (i.e., with both the daylight, and the tungsten lights switched on) for a specified working aperture. If the existing balance of daylight to tungsten is to be maintained for the most natural appearance on film of the actual situation, then the exposure reading taken should be used for both parts of the exposure independently. If a different balance between the two light sources is preferred, then the exposure time for each part can be adjusted accordingly.

The first part of the exposure for the daylight is likely to be supplemented by fill-in flash. Depending on the flash output necessary for the working aperture, the flash can be fired any number of times to reach the required output – either by firing it manually, if exposure time permits, or by dividing the exposure time into equal parts and letting the camera trigger the flash with each of a multiple of exposures.

For example, let us assume an exposure reading of 10 seconds for a working aperture of $f/22$ when using a

tungsten-balanced film rated at ISO 64. A flash reading of $f/6.7$ was taken at full output. In order to be an effective fill-in, the flash would have to be fired twice to increase its effective output by 1 stop to $f/9.5$, and half of this overall output again, i.e., one more flash, to achieve a further $\frac{1}{2}$ stop for an $f/11$ reading. This would mean firing the flash three times in all to create an effective output of $f/11$, which would be the recommended fill-in ratio of one-quarter the power of the available light.

The 10-second exposure and three flash output must next be increased by 1 stop to take account of the strength of the 85B filtration. A 1 stop increase requires a doubling of exposure time and flash output, so the exposure time would become 20 seconds and the flash output would become six flashes.

The daylight/flash part of the overall exposure could therefore be achieved, most sensibly, by firing the flash manually six times during the 20-second exposure. Alternatively, for the purpose of illustrating the point, this could also be achieved by multiple exposure in the following way: five exposures of 3 seconds each, and a sixth exposure of 5 seconds, each time triggering the flash unit(s) at full power. The tungsten part of the exposure would be for a straight 10 seconds.

The image in Figure 7.1 was a double exposure on daylight-balanced film. The first part of the exposure was for the flash alone, at a fast shutter speed without filtration; and the second part was for the ambient tungsten lighting with an 80A filter over the camera lens.

Mixed tungsten and fluorescent

When an interior is illuminated by a mixture of tungsten and fluorescent lighting – usually in a commercial or industrial building – the photographer should use a double or multiple exposure technique similar to the method outlined in the last section for daylight and tungsten.

Again, an overall light measurement should be taken with both light sources switched on, for a specified working aperture. Unless tungsten photographic lighting is used as a supplementary light source (in which case it should also be switched on when taking the light reading), any flash fill-in will have to be filtered appropriately. However, it is likely that interiors lit purely artificially will be large industrial sites

Table 7.1 Filters required to compensate for fluorescent and other forms of discharge lighting. Necessary exposure increase in *f*-stops is given

Colour compensation filters for fluorescent lighting

Type of lamp	UK tubes		Type of lamp	US tubes	
	Daylight-balanced film	Tungsten-balanced film		Daylight-balanced film	Tungsten-balanced film
Daylight	40M + 30Y + 1 stop	85B + 30M + 10Y + $1\frac{2}{3}$ stops	Daylight	50M + 50Y + $1\frac{1}{3}$ stops	85B + 40M + 30Y + $1\frac{2}{3}$ stops
White	30M + 20C + 1 stop	40M + 40Y + 1 stop	White	30M + 20C + 1 stop	60M + 50Y + $1\frac{2}{3}$ stops
Warm white	40M + 40C + 1 stop	30M + 20Y + 1 stop	Warm white	40M + 40C + 1 stop	50M + 40Y + 1 stop
Warm white deluxe	30M + 60C + $1\frac{2}{3}$ stops	10Y + $\frac{1}{3}$ stop	Warm white deluxe	30N + 60C + 2 stops	10M + 10Y + $\frac{2}{3}$ stop
Cool white	30M + $\frac{2}{3}$ stop	50M + 60Y + $1\frac{2}{3}$ stops	Cool white	40M + 10Y + 1 stop	60R + $1\frac{1}{3}$ stops
Cool white deluxe	20M + 30C + 1 stop	10M + 30Y + $\frac{2}{3}$ stop	Cool white deluxe	20M + 30C + $\frac{2}{3}$ stop	50M + 50Y + $1\frac{1}{3}$ stops

Suggested colour compensation filters for other types of discharge lighting

Type of lamp	Daylight-balance film	Tungsten-balanced film
Metal halide	40M + 20Y + 1 stop	60R + 20Y + $1\frac{2}{3}$ stops
Deluxe white mercury	60M + 30Y + 1 stop	70R + 10Y + $1\frac{2}{3}$ stops
Clear mercury	50R + 20M + 20Y + $1\frac{1}{3}$ stops	90R + 40Y + 2 stops
High-pressure sodium	80B + 20C + $2\frac{1}{3}$ stops	50M + 20C + 1 stop

or warehouses with sufficiently even illumination not to warrant any extra photographic lighting. An ambient light reading will give the necessary exposure for the photograph, and this will be the basis for each part of the double exposure as each light source is switched on and off independently. Using this same exposure for each part of the overall exposure will maintain the existing lighting balance of tungsten to fluorescent as they naturally appear.

Before the double exposure can take place, the appropriate exposure increase for the fluorescent part of the exposure must be calculated to take account of the necessary filtration, assuming a tungsten-balanced film.

For example, using a tungsten-balanced film rated at ISO 64, a light meter reading indicates an exposure of 10 seconds for a working aperture of $f/22$, with all the lights switched on. The tungsten part of the exposure will therefore be a straightforward 10-second exposure without filtration. The fluorescent lighting in this example is White Fluorescent. The colour compensation filter necessary to balance the colour of the fluorescent lighting to the tungsten-balanced film is CC 40M + 40Y, as read from Table 7.1. This filtration requires an exposure increase of 1 stop. Therefore, the fluorescent part of the exposure will have to be double the 10-second meter reading, making a 20-second exposure.

The double exposure would therefore work as follows. Switch off the fluorescent lights and expose the film at $f/22$ for 10 seconds without filtration. Next, reset the shutter and place filtration to the value of CC 40M + 40Y over the lens. Switch on the fluorescent lighting, switch off the tungsten and make a further 20-second exposure on top of the first.

Mixed fluorescent and daylight

This is the most common combination in office interiors and probably the hardest to correct with great accuracy. Working on daylight-balanced film without filtration would create an unpleasant green colour cast across the image. Filtering for the fluorescent would make the daylight coming through the windows appear magenta in colour. Several alternative solutions are possible, the simplest being to leave the fluorescent lighting switched off and to work with just a combination of daylight and flash lighting. Where daylight is

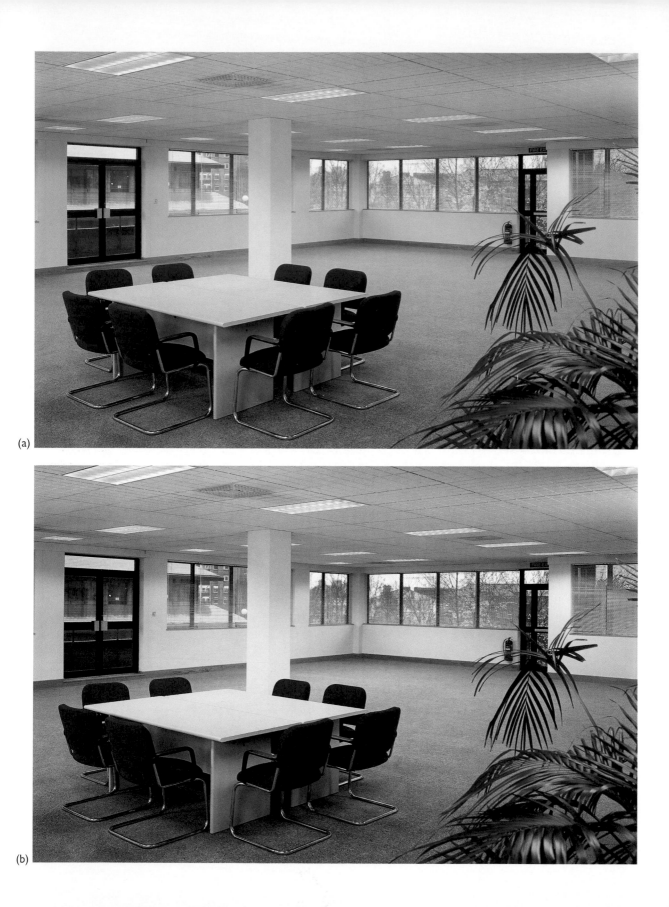

(a)

(b)

dominant, in combination with flash, it is also possible to leave the fluorescent lighting switched on with negligible effect on modern emulsions.

Alternatively, a double exposure can be used: the first part for the flash alone without filtration and the second part for the fluorescent and daylight with magenta filtration for the fluorescent. Inevitably, this produces a slight magenta cast on the daylight, but where the daylight is the secondary light source this can be negligible – see Figure 7.2(a) and (b).

A better solution is to shoot a triple exposure on one transparency. Switch off the fluorescent lights and make the first exposure for the flash alone, without filtration and at a fast shutter speed (1/125 second, for example) to render negligible the ambient light. The second exposure is for the daylight alone, with an appropriate green gel over the lens (typically CC 20G or CC 30G); and the third is for the fluorescent and daylight together, with magenta filtration (corresponding to the opposite of above, i.e., CC 20M or CC 30M) to neutralize the effect of the first green gel on the daylight. The second and third exposures must be exactly the same for the neutralizing process to work effectively. Take your ambient light reading with the fluorescent lights switched on. Add approximately half a stop to this light reading to compensate for the reduced light level of the second exposure when the fluorescent lights are switched off.

For example, an ambient reading of 1 second at $f/19$ with the lights switched on should be interpreted as 1 second at $f/16$ to compensate for this part of the exposure when the lights are switched off. The second and third parts of the exposure should therefore be for $\frac{1}{2}$ second at $f/16$, plus the recommended exposure increase in the region of half a stop to take account of the filtration (the CC 30G and the CC 30M filters recommend an exposure increase between $\frac{1}{3}$ and $\frac{2}{3}$ of a stop). This would make an exposure of $\frac{1}{2}$ second at $f/13$ for the second and third exposures on the single frame. Fill-in flash at 2 stops below a working aperture of $f/13$ would need to register a reading of around $f/6.7$.

To recap, using a constant aperture of $f/13$ the first exposure for the flash alone would be 1/125 second (with a flash reading of $f/6.7$); followed by a second exposure of $\frac{1}{2}$ second with a green filter over the camera lens and no flash or fluorescent lighting; and a final exposure, with the fluorescent lighting switched on, of $\frac{1}{2}$ second at $f/13$ with a

Figure 7.2 (*facing page*) Mixed fluorescent and daylight. Image (a) shows the effect of fluorescent lighting on film when left unfiltered, with its unpleasant green colour cast. Image (b) was a double exposure: the first part for the flash alone at a fast shutter speed and without filtration and the second part for the mixed fluorescent and daylight with 20M and 81A filtration over the camera lens. While the colouring in the interior has been suitably neutralized, notice how the daylight in the window now has a magenta cast over it. This was quite acceptable for the purpose for which the shot was taken, but had I wanted to completely correct all the colours, I would have had to use a triple exposure, neutralizing the magenta with green filtration for the daylight

magenta filter over the camera lens. Be sure to check the results on instant-print film, and then bracket the exposures when shooting the transparency film.

The best results can be obtained by the time-consuming business of covering each fluorescent tube with a sheet of gelatin daylight conversion filter. This would have the effect of balancing the colour of the fluorescent light with that of the daylight, avoiding the need for complicated multiple exposures and camera filtration.

8 PROBLEM INTERIORS

Problem interiors are those that deviate from the typical, average interior used to illustrate 'Technique in practice', Chapter 6. This deviation can be of size, structure or lighting. Difficulties can also arise with interiors that have no electricity or no furnishings. Those full of reflective surfaces require certain necessary precautions to be taken, to prevent unsightly flash reflections from appearing in the image. Various solutions to these problems are outlined to assist you in the day-to-day practice of this type of work.

Large interiors

Large interiors include open-plan office areas, factories, industrial warehouses, theatres and churches, for which the output from a couple of flash units could appear totally ineffective. There are three possible methods for dealing with such interiors. The first and simplest is to use the available light only. The second is to choose a camera position that enables you to hide several flash units within the picture area, thereby using the flash either as the dominant source or a very effective fill-in. And the third method is what is known as 'painting with light' whereby the photographer literally paints the interior with light from a flash or tungsten source while the camera shutter remains open.

Using available light

Photographing a large interior with available light only is both the simplest and fastest method, and often quite adequate for the use for which the photograph is being taken. For example, a photograph of a warehouse for a property brochure can often end up being printed around the same size, if not smaller, than the original transparency. This would

not warrant extensive subtle photographic lighting either in terms of quality or time. In fact, many such warehouses have very effective skylights along the length of their roofs that provide wonderfully even sources of white illumination over the whole interior, and that can often be supplemented further by opening their massive doors. If they do not have skylights, they will have some form of artificial lighting which, with simple filtration, should render an evenly lit image of sufficient quality.

Problems only arise when the large interior has a combination of both daylight through windows and artificial lighting, as discussed in the previous chapter.

Hidden flash lighting

There are often occasions when a relatively deep and narrow interior has to be photographed, with the deepest part disappearing into the shadows. The fill-in flash beside you will never penetrate deep enough without 'burning out' the furniture, floor and ceiling in the foreground, and the available light may also fail to penetrate the depths without causing excessive brightness in the rest of the image. In such

Figure 8.1 An example of hidden flash lighting. The fireplace was very dark within an otherwise dark interior. The only way to lift this was to lie a flash unit on the floor underneath the table at the far end, aiming it directly at the fireplace

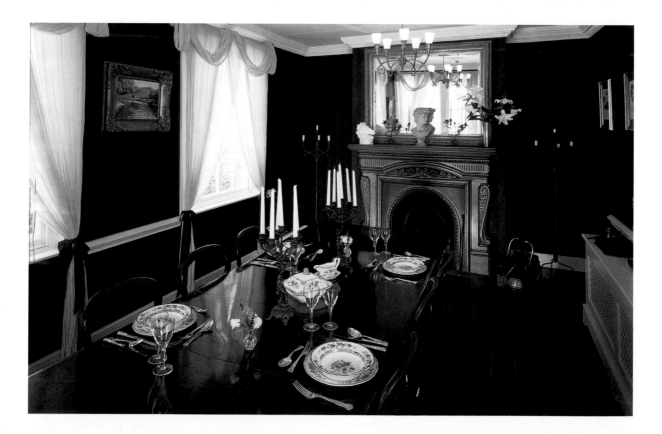

circumstances, the best remedy is to hide a flash unit within the picture area itself. Flash units can be concealed behind pillars or furniture, or hidden in doorways so long as nothing of the unit or its cabling is visible in the final image. The sight of any equipment, cabling or photographic lighting reflections in a photograph is an instant picture-killer and should be avoided at all costs.

Flash can be bounced off anything white, not necessarily an umbrella if there is insufficient space for it or it is causing an unsightly reflection. It can be bounced off a wall, the junction of the wall with the ceiling, white card or even woodwork if you are happy with a warmer light. In Figure 8.1 the dark dining-room interior caused the fireplace area to disappear into a black void without supplementary lighting. With one flash unit bounced off a white umbrella beside me, I was able to hide a second on the floor underneath the table, aimed directly at the fireplace. The result picks out all the detail of the fireplace with great clarity. For illuminating such small dark areas within the picture area when there is not sufficient space to conceal a flash unit, a portable flashgun with a slave unit (a flash-sensitive triggering device) attached is a small, handy and very easily hidden source of flash light without any cabling.

'Painting with light'

When you require even illumination of a large, dark interior without having to set up and conceal many flash units within the picture area, it is possible to use a very long exposure during which time you literally 'paint' the interior with light from either tungsten lamps or flash units. This creates a shadowless light and requires the photographer to walk around the interior painting the light or firing the flashes from within the picture area itself.

In order to make this long exposure, use the 'T' shutter setting on the lens as, once fired, this will hold the shutter open until the cable release is pressed a second time. If there is no 'T' setting on your lens, use the 'B' setting in conjunction with a locking cable release. Once fired, the screw lock will hold the shutter open while you are away from the camera. Releasing it on your return will close the shutter.

For example, I used this technique to illuminate the church in Figure 8.2. The church itself was suitably dark and gloomy with the lights switched off, which enabled me to use

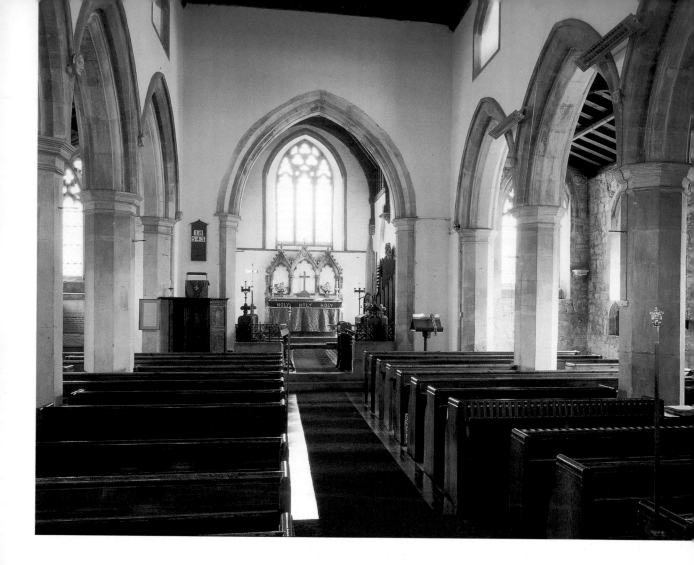

Figure 8.2 Mursley Church, Bucks. A 60-second exposure was used during which time I 'painted' the interior with light, walking around within the picture area firing a flash unit. I wore dark clothes and kept moving throughout to prevent my own image appearing on film. My 'painting' sequence is illustrated in Figure 8.3

a 60-second exposure at $f/16$ with an 85B filter over the lens. This gave me just enough time to get around the full interior, with negligible reciprocity failure on tungsten-balanced film rated at ISO 64. If the ambient light is too bright for a long exposure, neutral density (ND) filters can be used over the camera lens to reduce the intensity of light reaching the film plane (see Table 9.1). However, they also reduce the intensity of the flash light reaching the film, which means more power will be needed from the flash units. This is most simply done by firing them more times within the extended exposure time.

The painting sequence I used is illustrated in Figure 8.3. It is essential to work out the most appropriate painting sequence in advance in order to illuminate the interior evenly and efficiently in the limited time available. It is also practical to position beforehand two or three flash units, or tungsten

lamps, in concealed positions, in order to keep power cables to manageable lengths and prevent their image appearing on film. The placing of these units will be dictated to a large extent by the location of power points. The church in Figure 8.3 had only two power points: one in the nave and one in the chancel. Concealed places near to these points were therefore used to hide the units when not in use during the exposure. Their slave units were switched off so to prevent them being triggered by other flashes.

As already mentioned, this technique involves walking around the interior during the exposure. The golden rule, therefore, is to wear dark clothes and keep moving so as not

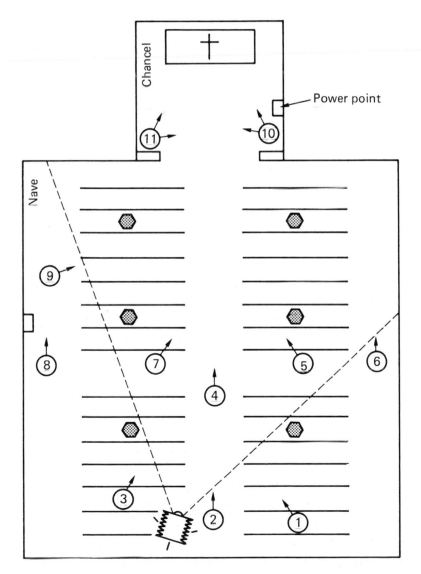

Figure 8.3 The 'painting' sequence used to photograph Mursley Church in Figure 8.2

to be recorded on film. Fire the flash as you move, and make sure the unit is never aimed in the direction of the camera.

The flashing, or painting, must be balanced between the two sides of the interior, assuming a symmetrical arrangement, and as evenly as possible in all circumstances. Avoid firing the flash or painting the tungsten light too close to foreground furniture when illuminating more distant areas, as you do not want any element artificially burnt out on the image.

Use the flash or tungsten direct, and determine the exposure by metering the ambient daylight for the pre-determined working aperture. If it is less than 60 seconds, it may be worth reducing the aperture size further to increase the exposure time. Once established, you can then work out the necessary amount of flashes, or length of painting time, for each area, in order to create effective fill-in lighting. Base this last calculation on average flash or light readings from one of the units across two different distances, one shorter and one longer, that are likely to be used for the illumination.

The $f/16$ aperture for the church example effectively required a light output for an $f/22$ aperture to account for the approximate 1 stop exposure increase necessary for the strength of filtration. For the flash to act as a fill-in, the output would have to be suitable for an aperture 2 stops wider than this, i.e., $f/11$, to reduce its effect to a quarter that of the ambient daylight. To achieve this output, I fired the flash twice for the shorter distances, and four times for those further away, but never with clinical precision as I was moving throughout.

The strength of this technique is that it enables you to illuminate very large areas with a minimum number of photographic lights. Its corresponding weakness, however, is that inevitably it is not 100 per cent accurate either in terms of exposure or perfectly even lighting, all of the time. For this reason, it is most effective as a fill-in form of lighting where its output is subsidiary to the dominant daylight. This has the added advantage of retaining the most natural appearance of the interior on film and demands the minimum flash output.

Examine the effects on instant-print tests very closely before exposing the actual transparency or negative film, and use the instant-print as a valuable secondary exposure guide. Bracketing with this technique is awkward, so I would recommend having your transparency films 'clip tested' instead.

Clip testing

'Clip testing' is a useful facility offered by professional laboratories in order to achieve a perfect result on film so long as reasonably accurate, consistent exposures were maintained throughout the whole roll of film. When a film is clip tested, approximately the last frame is cut off the film and processed separately in the normal way. The result is viewed and assessed for perfect exposure. If the clip test is perfectly exposed, the rest of the roll can then also be processed normally. If the image on the clip is slightly over- or underexposed, the variation from perfect exposure is estimated in *f*-stops and the film development adjusted accordingly. A further clip test can then be taken to confirm the adjustment if you are not absolutely confident of the judgement that has been made. However, each clip test eats further into the film, reducing the number of frames left for perfect processing.

Film development time can be either shortened ('pull-processing') if the clip test was over exposed, i.e., too bright, or lengthened ('push-processed') if the clip test was underexposed, i.e., too dark. Push- or pull-processing by up to 1 stop should yield excellent results, correcting exposure within what is effectively a 2-stop band around the perfect exposure. Wider than this, contrast is reduced with pull-processing and colours shift towards blue. Conversely, with push-processing, contrast is increased along with graininess and fog levels, and colours shift towards red.

The only minor disadvantages of clip testing are that it doubles the process time as the two parts of the film are processed separately and it incurs a little extra cost. It should, however, yield a greater quantity of correctly exposed images per film than that achieved by bracketing alone, but is only useful when conditions of lighting and exposure are kept constant for the whole film.

Small interiors

The first problem with small interiors such as bathrooms, cramped kitchens and the like is finding the best position (often the only position) from which to take the photograph, in order to include enough of the elements in the room for it to yield a sensible, representative image of that interior. This can still be a problem with even the widest-angle lens.

Having found that position, the next problem is to actually erect the tripod within such a confined space. Often

Figure 8.4 In a small interior, you can use just the available light if it is all artificial and can easily be filtered

the doorway is the best place to work from, as the camera can be placed as far back as possible to the point of maximum room coverage (without clipping the door frame). You will also be less cramped as you will actually be standing outside the room.

Having set up the camera in the most suitable position in the circumstances, lighting is the next consideration. Two basic options are open to you. First, you can use just the available light if this is all artificial and can be easily filtered (as in the case of the lift in Figure 8.4); second, you can use flash as either a dominant or fill-in light source. The first option is obviously the simplest, quickest and often the most effective. The problem with the latter is where to place the flash unit in such cramped conditions without being visible from the camera position and without causing any

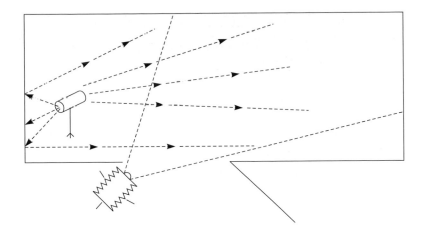

Figure 8.5 Photographing a small interior can be problematic because of lack of space. Placing the camera in the doorway, and tucking a flash unit into the corner of the room, can provide an effective solution

unacceptable umbrella reflections. Often the flash unit can be tucked into a corner either just within the room, if the camera is in the doorway (see Figure 8.5), or right up beside the camera if the camera is actually in the room.

There is often not room for an umbrella reflector or softbox, but this is no disadvantage if the wall and/or ceiling are white as it is usually more subtle to bounce the flash off the junction of the wall with the ceiling. This is because the flash light will be coming in from a similar angle to the way it would have been reflected off an umbrella, but without any possibility of an ugly umbrella reflection. The reflection (if there is one) of a glow off the far wall is much more aesthetically acceptable – see Figure 8.6.

If flash is to be used, the best technique is to use it as a fill-in. If the interior is otherwise completely artificially lit, the best results are obtained by using a double exposure: one fast exposure just for the flash (and with the artificial lights

Figure 8.6 Where space is limited within a small interior, or where an umbrella reflection in a window or picture is inevitable, bouncing the flash off the junction of the wall and ceiling is an effective alternative. Any reflection this might cause will be more subtle and therefore more aesthetically acceptable

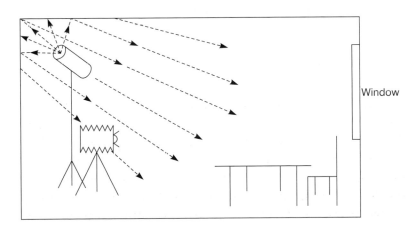

Window

switched off if possible) and a second, longer, exposure with the lights switched on and the appropriate filtration over the lens. Burning in the available light without filtration will only create an unpleasant colour cast over the whole image. This is also the best technique for photographing internal corridors where there is nowhere to conceal any flash units, other than beside the camera to add a little extra light in the foreground, as in Figure 7.1.

Empty interiors

Empty interiors are always a challenge. In my experience they frequently seem to be recently developed, large open-plan office areas with dull-coloured carpeting, fluorescent lighting and a series of structural pillars. The combination of pillars and lights can be used to reasonable effect to create an impressive perspective shot, with the diminishing pillars and receding rows of lights leading the eye into the picture from both sides. This is best achieved by standing approximately one-third of the distance along the wall from the corner, to include three walls in the final image.

Figure 8.7 The perspective of pillars and rows of ceiling lights can add an abstract interest to a modern, empty interior

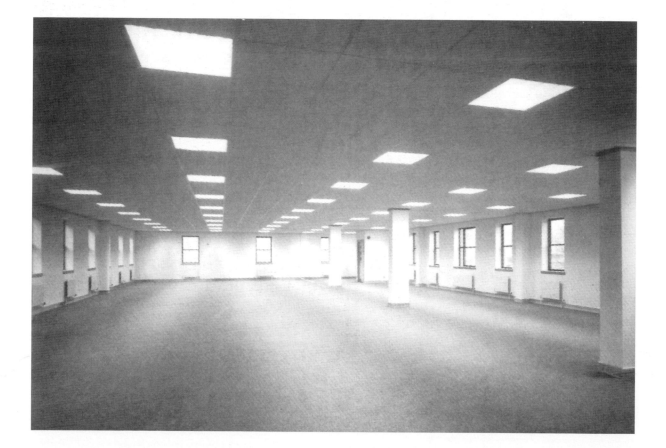

While such shots are suitably effective for the purpose for which they are usually used, they can be dramatically enhanced – as can any photograph of an empty interior – by direct sunshine creating abstract window patterns across the otherwise plain floorspace. The effect of these impressive patterns not only suggests a permanently bright and sunny interior, but also breaks up the empty space with an abstract dynamism similar to that created by furniture in a room. This works both for a general view of the interior and also for an interesting detail shot of a window, or row of windows, with their corresponding sunshine patterns. Such patterns are richest in colour, longest and reach furthest into the room either early in the morning or late in the afternoon, and in the winter months owing to the lower elevation of the sun.

Light readings for interiors with direct sunshine should be taken, as usual, of the general ambient light in the interior and

Figure 8.8 Sunshine is the ultimate saviour in an empty interior. The window patterns created by direct sunshine can break up the space with an abstract dynamism similar to that created by furniture in a room

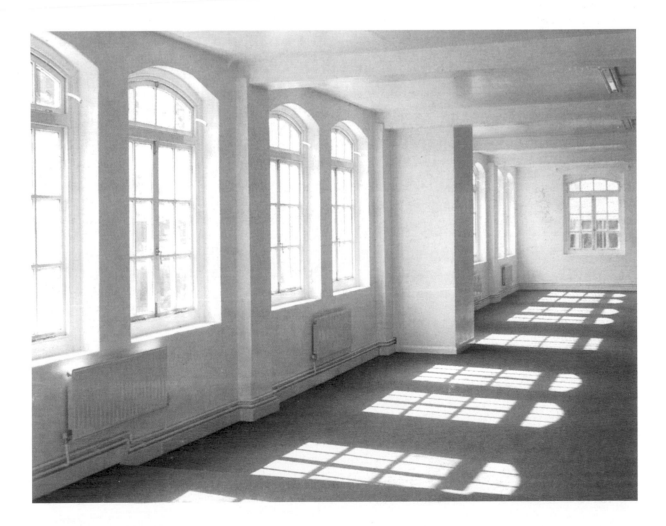

not from the sunny areas. This is because we want the sunny areas to record brightly, even slightly burning out on the film, as this is how they appear to the naked eye. If the sunshine patterns appear too burnt out on the instant-print test shot, you can always reduce the exposure time (or aperture size, if appropriate) and correspondingly boost the flash output to effectively reduce the brightness of the direct sunshine.

In summary, to get the best out of an empty interior, it is worth choosing a day with full sunshine (which will, of course, help with any exterior work you might also be doing). With the help of a compass or plan, work out a shooting sequence that makes the best possible use of that sunshine.

Interiors with no electricity supply

When you have to photograph sites that are either not fully completed, or that have been unoccupied for any length of time, it is likely that either the electricity has not yet been installed or has been disconnected awaiting a new tenant. In either circumstance, you are left with the limitation of being unable to use your mains-powered flash units.

These circumstances seem to arise most frequently on commercial sites with large interiors. The only realistic option open to you is to stretch the available daylight as far as possible. Allow the window areas to burn out, if that is necessary, to create sufficient illumination for the interior to be clearly visible. The use of a portable flashgun, fired direct from the camera position, will act as a modest fill-in and can brighten up the foreground with exaggerated effect when using a wide-angle lens, because of the perspective distortion that this lens creates.

In a small to average size interior a portable flashgun can also be used as a direct fill-in, or more effectively bounced off a wall or ceiling. Its output can be boosted by firing it several times either on a long, timed exposure, or by using several shorter exposures on a single frame to build up sufficient flash output to achieve satisfactory fill-in lighting.

Poor daylight conditions

There are times when interiors have to be photographed without the perfect conditions of sunshine or even bright daylight. Pressure on a photographer's time and unpredictable weather conditions make this inevitable. There are two possible paths to follow to create the impression that there is a bright day outside.

Figure 8.9 (*facing page*) Poor daylight conditions. Image (a) shows an interior photographed on a dull, grey day, using available daylight and flash fill-in. In (b) an 81B 'warming' filter has been placed over the camera lens to warm up the colour of the light

The first, and simplest, way is to take an available light reading in just the same way as you would on a bright day. You will need a longer exposure than usual, which does not present a problem so long as that exposure falls within the tolerance of the particular film you are using. You can then place an 81B 'warming' filter over the camera lens to warm up the colour of the otherwise cold, dull-grey light. This will create on film the appearance of warm, bright and diffuse light filling the room – see Figure 8.9(a) and (b). It will, of course, also warm up the colour of any fill-in flash. This, however, is only very subtle and usually enhances the atmosphere, especially of a residential interior, by giving it an added welcoming warmth. Once again, when using any filters, do not forget to increase the exposure by the appropriate factor.

The other possibility is to place a tungsten lamp or flash unit outside the window to act as an artificial sun. This will have the effect of creating sunny window patterns across the interior and is most effective when photographing either a small interior or a small part of an interior. While natural sunshine would usually be the preferred choice, artificial sunlight does have the added advantage of being totally under the control of the photographer. Whereas the sun is constantly moving (and it is amazing just how fast it does move when you are busy setting up the camera, taking light readings and shooting instant-prints), the tungsten light is obviously stationary for as long as the photographer requires it, and it can never disappear behind clouds! It can be angled from any direction to simulate any chosen time of day. It can also be filtered to varying degrees, with the appropriate combination of blue gels for tungsten lighting and amber gels for flash lighting, to suit the angle chosen or amount of warmth desired. The higher the angle, the whiter the light; the more horizontal the angle, the more orange the light should be if it is to adequately simulate the real sun.

Tungsten lamps powered at between 1000 and 2000 watts are suitable for this work. The reason this alternative only really works well in small interiors, or for details of interiors, is because the light fall-off in a large interior would look unnatural and would also require one lamp for each window in shot, set at precisely the same angle, and taking great care to avoid any double shadows.

Interiors full of reflective surfaces

Reflective surfaces always provide a challenge for the photographer. Working out a way to overcome the problem of flash reflections, or even your own reflection (in a small mirrored bathroom, for example), can be a time-consuming and precise business. This section will outline a few helpful techniques to deal with such problems.

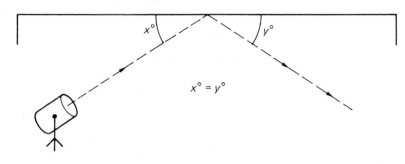

Figure 8.10 Light travels in straight lines and reflects off any flat surface at the same angle to that surface as the incoming light, but in the opposite direction. This is essential to keep in mind when placing lights, in order to avoid reflections

It is important to remember that light travels in straight lines and reflects off any flat surface at the same angle to the surface as the incoming light, but in the opposite direction (see Figure 8.10). For the flash unit not to cause unsightly reflections in a shiny wood-panelled room, for example, you would have to place yourself in one corner of the room, shooting towards the opposite corner, with the flash unit(s) beside you (see Figure 8.11). This will prevent any direct reflections from coming back towards the camera. Reflection from window light is usually quite acceptable as it a natural light source.

The same principle applies to other reflective surfaces: paintings, picture glass, windows in the picture, etc. Some

Figure 8.11 Reflective surfaces. Placing the camera and flash unit(s) in one corner and shooting towards the opposite corner avoids the problem of reflections in a shiny wood-panelled room, as shown in (a). A less diagonal position, as in (b), would cause the flash to be reflected back towards the camera, causing obvious light spots on the panelling

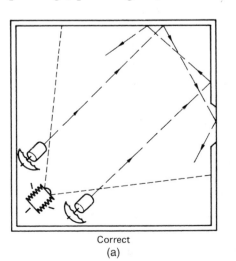
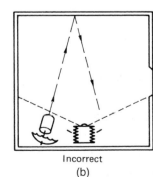

Correct
(a)

Incorrect
(b)

modern offices have glass wall partitions on two or three sides, with a window on the fourth. These can cause havoc with secondary and tertiary reflections bouncing around the room, even if you have been careful to position yourself so as to avoid any direct reflections.

Where wall mirrors present a problem, as in small bathrooms, the photograph of the interior can be taken from an angle looking into the mirror itself, to include the area surrounding the mirror as well (see Figures 8.12 and 8.13). This effectively transforms the problem to your advantage. Photographing into the mirror from an angle, including the hand basin in the foreground, not only creates an unusual and imaginative shot, but also enables you to include most of the significant elements within the room, which would otherwise be impossible to achieve. In other words, your final image will be an original, exciting photograph that best conveys the essence of that interior. There will also be no problem reflections as you are using the reflective surface itself as part of the photograph.

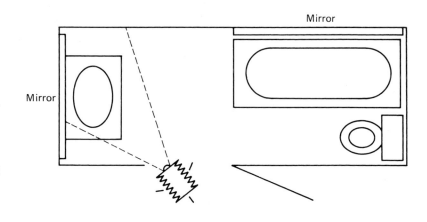

Figure 8.12 Large mirrors in small interiors, such as bathrooms, can be problematic. It is possible, however, to use them to your advantage by photographing the reflection of the interior in the mirror, from an angle. By including the basin, or area surrounding the mirror, this method can sometimes enable you to include all the significant elements within the room, which would otherwise have been impossible to achieve

If you have the problem of a flash reflection in a picture glass, there are two possible solutions. Either shift the offending flash unit sufficiently so that it is just not reflected, or tilt the picture frame by lodging a crushed film paper or box behind it.

Bedrooms

I have chosen to include bedrooms as problem interiors for the simple reason that the main feature of the room, the bed, is often so dominating that it can easily obscure the other

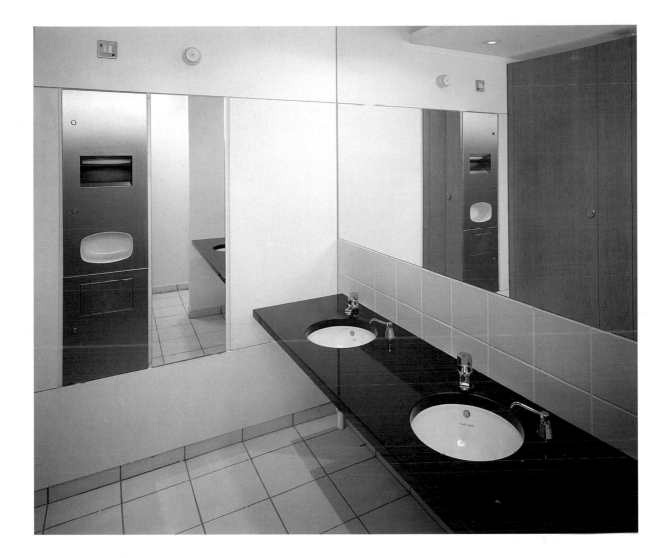

decorative features of the room. Remember, you do not have to include the whole of the bed in the image to show that it is a bedroom you are photographing. Try and avoid the conventional diagonal view towards the massive bed where possible, and instead find a more original angle. A shot that cuts across the corner of the bed in the foreground, looking towards the rest of the room in the background can be a good choice. The viewer can still see it is a bedroom, but the result is a much more interesting and rewarding shot.

Staircases and stairwells

Staircases can initially appear problematic: they can look somewhat dull and uninspiring from ground level. However, there are certain places on most staircases from where one

Figure 8.13 An image of an office bathroom, using the technique shown in Figure 8.12. The mirrors also enhance the apparent size of the room

PROFESSIONAL
INTERIOR
PHOTOGRAPHY

can create some of the most interesting interior photographs possible, often with abstract and dynamic effect.

The best place from which to photograph a staircase with a double flight of stairs is often from the half-landing, using a wide-angle lens. From this point you can embrace within a dynamic composition both the banister rising to your level and the stairs leading up away from you. This both yields the best interpretation of the structure of the staircase and prevents any problems of converging verticals. It is best to light such shots from both the floor below and the floor above to prevent either part of the staircase disappearing into a shadowy abyss.

Figure 8.14 Three different treatments of staircases. In (a) a half-landing on the staircase provided the best vantage point for a dynamic picture of its construction; (b) (*facing page*) an alternative treatment is to look down the staircase towards the atrium area below; and (c) (*page 124*), the final staircase was shot from the top looking down the stairwell, illuminated by flash from a similar position at every level

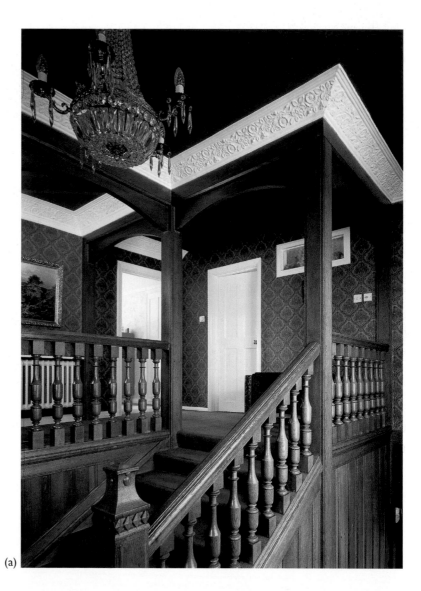

(a)

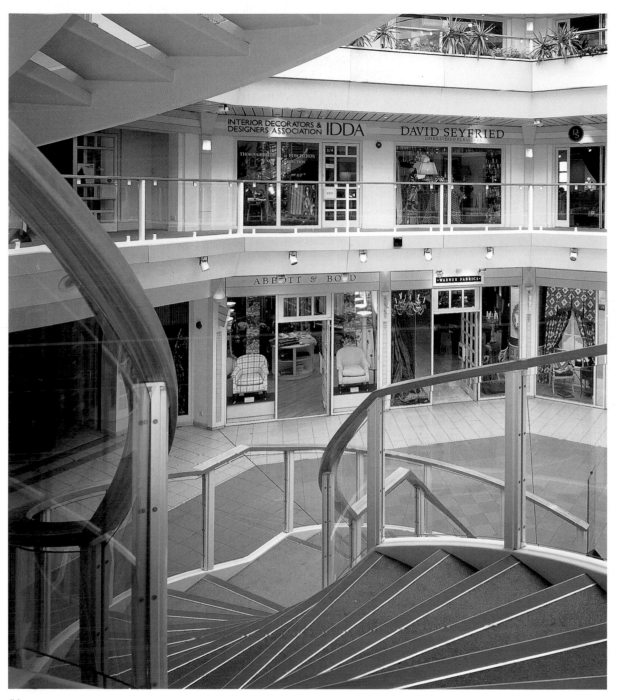

(b)

Figure 8.14 (*continued*) (c)

PROFESSIONAL
INTERIOR
PHOTOGRAPHY

◼

124

A dramatic technique for photographing a stairwell is to either shoot it from the bottom looking vertically up the spiral to a possible skylight at the top, or to climb to the top and shoot directly down the full spiral. In either case, if sufficient flash units are available, it is best to illuminate the staircase from a similar position (i.e., out of view on the same side of the stairwell as the photographer) at every level.

9 CREATIVE TECHNIQUES

The previous chapters have established various approaches with a diversity of techniques to enable you to photograph most interiors that you are likely to encounter. By now, you should be starting to feel in tune with the whole process and language of interior photography, from which your own individual approach to interiors can be confidently generated. Within this framework, we can now go a step further and look at some creative effects that can be employed to enhance your images.

Balancing the interior and exterior light to show the outside view

A key feature of an interior can, on occasion, be the view outside the window. This can be an exquisite garden or countryside in the case of a residential interior, an important view of the rest of the complex from an industrial or commercial interior or, in the case illustrated in Figure 9.1, an important city view.

Employing the regular 'fill-in' technique as described throughout this book, whereby the daylight through the window is treated as the dominant light source, will usually cause the view outside any window to be burnt out, i.e., to be so bright as to bleach out much of the colour or detail in the external view. This clearly has its advantages, especially in built-up areas, where the external view is often best burnt out by overexposure. However, when you want to retain the rich colours and detail of the view outside, a different balance has to be employed. As you might imagine, this should be based around an approximately equal balance of the interior and exterior light intensity, with a slightly brighter intensity outside than in.

Having determined your working aperture, take a light reading from the window of the external view for an aperture half a stop smaller than the working aperture, for example *f*/19 instead of *f*/16. This will give you an exposure that will record the external view on film as half a stop brighter than the interior lighting.

The reason for a half stop, or even a full stop, difference between the interior and exterior light intensity is to create on film the most natural appearance possible. We expect the outside view to be brighter than the light level inside, so this produces that illusion without damaging the detail of the view or weakening its colours too much. The exposure required will be much shorter in duration than we are used to using. This therefore means that the interior will largely be illuminated by a combination of flash and any direct sunshine in the room, rather than the usual burning in of available light.

Figure 9.1 Balancing the light to show the outside view. Here it was important to set this boardroom image within the context of its City location

If the flash output needs to be built up by firing the flash units more than once, this will have to be done by double, or multiple, exposure. For example, with a working aperture of $f/16$ and a corresponding exposure reading of $\frac{1}{30}$ second (at $f/19$, for a brighter external view), a flash with a single output reading of $f/8$ will need to be fired four times (twice to take it up to $f/11$, and double that, i.e., four times, to increase the output for an $f/16$ aperture). In order for the flash to be fired four times, four exposures will be necessary, each at one-quarter the duration of the metered $\frac{1}{30}$ second, i.e., at 1/125 second (being the calibration on the camera that is approximately one-quarter the duration).

Unless working on a detail area surrounded by windows, you are likely to lose some of the natural atmosphere of the interior that would have been created using the fill-in technique. This is the compromise that must be made if the external view is an important feature to be included in a particular interior.

Figure 9.2 (*facing page*) Balancing the lighting of other rooms in view. Image (a) shows how the power of the flash, in combination with the available light, has rendered the internal room dark. The addition of a flash unit bounced off a white umbrella inside that room brings the image back to life, as illustrated in (b)

Balancing the lighting of other rooms in view

An interior image will often show a view through to another room, albeit in the distance. If this is not filled with sufficient natural light to record brightly on the test shot, you will have to balance the lighting in this room with that of the interior you are photographing. This is usually done, quite simply, by concealing an extra flash unit within that room, and adjusting its output accordingly. The example illustrated here (Figure 9.2) is an extreme case where there is a window into an internal room. The power of the combined flash and available light in (a) rendered the available artificial lighting in the internal room ineffectual. It is a nice enough image, but with a dark hole in the middle of it. The addition of a flash unit bounced off a white umbrella inside that internal room brings the image back to life, as illustrated in (b).

Creating a night scene

Clients will sometimes ask for a residential interior to be photographed as a night scene, be it a bedroom, living room or dining room. This can easily be achieved during the day as Figure 9.3(a) and (b) demonstrates: the night shot being taken immediately after the daytime shot.

(a)

(b)

(a)

(b)

With a daytime shot, daylight is likely to be the dominant light source, with subtle flash fill-in to reduce the contrast. Conversely, with a night scene, all daylight must be shut out, and the artificial room lights and lamps should appear the dominant source, even if the flash is actually dominant. This, therefore, requires the curtains to be drawn and the lights to be switched on. The curtains should preferably be lined to reduce daylight penetration to a minimum.

You will probably also have to alter the position of your flash unit(s) from the daytime shot. You no longer wish to be too directional with your photographic lighting (assuming that you were filling in from the same direction as the dominant daylight), and further units may need to be added to even out the lighting. You can use the flash to fully illuminate the interior, burning in just enough of the available light from the tungsten room lights and lamps to create a natural, warming glow around them without creating too strong a colour cast. To determine the length of exposure, take generalized light readings for the working aperture from the room as a whole. Shoot an instant-print to assess whether the balance of flash to tungsten is appropriate both in terms of natural appearance and colour. Increase or reduce the exposure time relative to the flash output according to your interpretation of the instant-print.

When more critical colour rendition is required, you will have to use a double exposure technique (similar to those described in Chapter 7) on tungsten-balanced film. The first part would be a fast exposure for the flash (say, $\frac{1}{250}$ second), with an 85B colour conversion filter over the lens; and the second part a longer exposure for burning in the available room lights, without filtration. Use the flash as a strong fill-in light source, perhaps starting off with it at half the strength of the available light instead of the usual quarter under daylight conditions. It is also possible to use daylight-balanced film instead, with no filtration for the flash, and an 80B colour conversion filter for the second, tungsten, part of the exposure.

Highlighting a feature

There are occasions when a significant element or specific area within the interior needs to be subtly highlighted – be it a product within a setting, a painting or an attractive vase of flowers, for example, as demonstrated in Figure 9.4. You can

Figure 9.3 (*facing page*) Creating a night scene. These two shots were taken one after the other and demonstrate the different lighting effects required for this transformation. In (a), the daylight was the dominant light source, with subtle flash fill-in to reduce contrast. In (b), the room lights appear to be dominant, though plenty of soft flash is actually illuminating most of the scene

Figure 9.4 Highlighting a feature.
These flowers were highlighted with a
honeycomb diffuser and the scene filled
in with flash reflected off an umbrella

create highlights of differing shapes and sizes by placing a
variety of readily available diffuser and snoot attachments on
the flash unit or tungsten lamp. Diffusers concentrate a soft,
square light onto a specific area, which can be finely
controlled and shaped with the use of 'barn doors' (hinged
flap attachments to the front of the diffuser). Snoots, on the
other hand, create very directional, circular spots of light.

Setting a room in context

When asked to photograph an interior, one usually antici-
pates photographing it within the confines of its four walls. A
more imaginative approach, certainly for uninspiring office
interiors, is to set them within the context of the building of
which they are part. One can achieve this by including within
the shot part of the doorway or passageway leading to the
room, as shown in Figure 9.5.

People in interiors

The majority of interiors photographed are empty of people in order to concentrate the eye specifically on the interior detail rather than any people within it. However, people are sometimes integral to the interior, usually in commercial or industrial situations. Sometimes magazine features also like to include a photograph of the individuals within their interiors.

In commercial and industrial situations, there are three basic options open to you. The first is to freeze all action within the interior by having people carefully posed to look as natural as possible, even if the suggestion is one of action. This is a useful technique when either clear identification of the individuals or the processes in which they are involved is an important part of the brief.

A more interesting and dynamic approach is to allow the people within the interior to continue their activities. Using

Figure 9.5 An example of setting an office within its context to create a more imaginative image

Figure 9.6 The blurred movement of activity within a static interior can be achieved by using longer exposures, typically between $\frac{1}{4}$ and 2 seconds. This works especially well when using a combination of flash and long exposure. The flash freezes a clearish outline of the individuals, and the longer exposure captures their subsequent movement

exposures between $\frac{1}{4}$ and 2 seconds, you can capture on film the essence of their activities within an otherwise static interior setting. This works especially well when using a combination of flash and long exposure as the flash freezes a fairly clear outline of the individuals (depending on how close they are to a flash unit), and the long exposure captures their following movements in a blur of activity – see Figure 9.6. This can be used to great effect to produce some startling images. It enhances the atmosphere of the interior without allowing the distraction of individual personalities within it, and has the added advantage from the point of view of stock photography as it avoids the need for model releases before the pictures can be published.

The final option is to eliminate on film the recording of the people in the interior, for example in a large busy shop. This is done by using very long exposures with just the available light, so that brief movements in and out of the image area fail to record on film. If the interior is brightly lit, and with even a small aperture the exposure reading is only a few seconds, then you can place a neutral density (ND) filter over the lens. This is a plain, colourless grey filter of a specified factor that reduces the level of light reaching the film by that factor (e.g. ND × 2 requires a doubling of exposure), without in any way affecting the colour or contrast of the original image. An exposure of between

Table 9.1 Neutral density filters.

Standard ND filters	ND filter	Percentage of light transmitted	Exposure factor increase	Actual exposure increase
	0.1	80	× 1.25	$\frac{1}{3}$ stops
	0.2	63	1.5	$\frac{2}{3}$
ND × 2	0.3	50	2	1
	0.4	40	2.5	$1\frac{1}{3}$
	0.5	32	3	$1\frac{2}{3}$
ND × 4	0.6	25	4	2
	0.7	20	5	$2\frac{1}{3}$
	0.8	16	6	$2\frac{2}{3}$
ND × 8	0.9	13	8	3
	1.0	10	10	$3\frac{1}{3}$
	2.0	1	100	$6\frac{2}{3}$

The standard ND filters are shaded in grey, and are popularly referred to by their exposure factor: ND × 2, ND × 4 and ND × 8

30 seconds and 1 minute should prevent most movement, and therefore people, from being recorded on film. The only people who will be recorded are those who are relatively static for the duration of the exposure. In the example of the busy shop, this could be the sales assistant. Clearly, this should be taken into account when using the technique.

Bringing fireplaces to life

Unless fronted with an interesting firescreen, or elaborate display of dried flowers, fireplaces in interior photographs can easily appear as dense black voids because of their matt black, highly light-absorbing quality. The contrast of this black void with the rest of the room can be an unsightly blot on the final image unless brought to life in one of two ways.

The simplest way to bring life to a fireplace is to light the fire, either with genuine coal or logs (though these take a long time to glow and can make conditions unbearably hot in the warmer months); using gas if it is an artificial log or coal fire (these also need to be left on for a while to glow, though they are much faster than the real thing); or very simply by burning knotted sheets of newspaper in the grate. Do not forget to open the flue when lighting any fire.

Knotted newspaper lights and burns with dramatic flare and intensity for the short duration of the actual exposure.

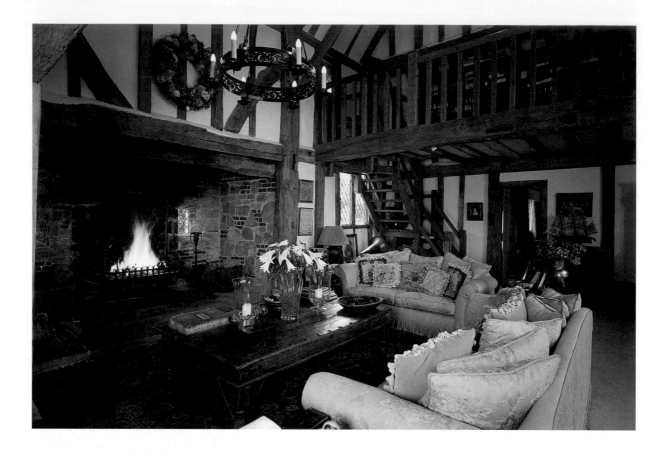

Figure 9.7 A fireplace can be brought to life by lighting the fire. If gas is unavailable, burn knotted newspaper in the grate. The longer the exposure, the more blazing the fire appears on film

It is usually possible to manage four or five exposures with one burn of paper, so to achieve a full roll of 10 or 12 frames it might be necessary to light two or even three separate newspaper fires. The effect is dramatic: the longer the exposure, the more roaring the fire appears on film as a result of the greater recorded movement of the flames.

The occasional use of a starburst filter

All special effects filters should be used sparingly as they tend, by their very nature, to lack subtlety. On occasions they can, however, animate a shot in spectacular fashion. This is especially true of the starburst filter when you want to exaggerate pinpoint light sources. While lenses will often create subtle, mini-starbursts without filtration, the grids of angled lines etched into the starburst filter produce a much more dramatic effect. A good example is the setting sun in Figure 9.8, where the starburst adds an extra dynamic impact in an otherwise empty, and potentially dull, office interior.

The filter can be twisted round to adjust the angling of the starbursts which are often most effective when not

aligned vertically or horizontally. Do test the actual effect on instant-print film as the starbursts grow and diminish in size in direct proportion with exposure. Their size can be adjusted by altering the ratio of the available light to that of the flash.

Figure 9.8 The use of a starburst filter here adds drama to an otherwise empty, and potentially dull, office interior

Creative angles and unusual vantage points

Many modern interiors lend themselves to photographic interpretation in a number of different ways. There are always the essential conventional shots to be taken, showing the full scope of the interior from approximately eye level. However, around these base shots, further experimental shots taken from novel and creative angles can be tried. The client will always want to see the conventional shots as they are the all-important informative photographs, the mainstay of the feature or brochure. They are also the safeguard that allow

(a)

Figure 9.9 Creative angles and unusual vantage points. Image (a) was taken looking up this atrium, and the camera twisted to maximize the dynamic lines within the shot.

you to experiment with different approaches once you have these under your belt.

A high vantage point often throws an interesting perspective on an interior. Maybe this can be done from one or two floors up an atrium, or from half way up a staircase. Overlooking an interior from a high viewpoint renders a more abstract composition. Exploit this abstraction, forget about lens shifts and allow the verticals to diverge to the full. Try tilting the camera on its side by 45° to add further dynamism to the lines within the composition. Treat the whole exercise as a creative process of abstract picture composition while incorporating the essential elements of the interior.

(b)

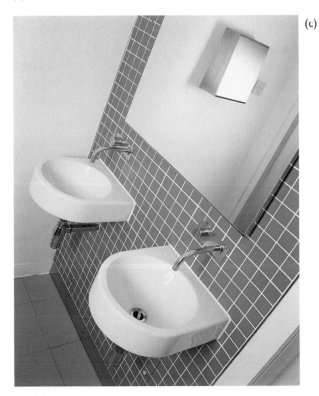

(c)

Figure 9.9 (*continued*) Image (b) shows the opposite effect, with a view down an atrium; and (c) demonstrates how tilting a camera through approximately 45° can create a stimulating image of an otherwise uninspiring interior, with dynamic impact

PROFESSIONAL
INTERIOR
PHOTOGRAPHY

139

Another approach is to photograph an element of the interior from an oblique angle for dramatic and more abstract composition. You can also try shots from very low angles, especially if an interesting ceiling or atrium skylight are an integral part of the interior.

Depending on the client, the purpose for which the photographs are being taken, and the success of your experimentation, a semi-abstract interior photograph taken from an unusual, creative angle can often be that imaginative spark that lifts the whole tone of a brochure or display. Furthermore, it stretches the imagination and creative ability of the photographer and can provide stunning, eye-catching images for a portfolio.

10 PRESENTATION AND STORAGE, FILM AND DIGITAL

The criteria for image storage are quite different for the two alternative mediums, so they will be treated separately in this chapter. The only time the two technologies come together is when the image is shot on film and then scanned into digital form. The separate film and digital versions are then stored accordingly.

Film

While the quality of the photographs themselves, be they colour transparencies or prints, is of paramount importance, the significance of their presentation cannot be overstated. An excellent set of photographs poorly presented to a busy editor probably stands the same chance of publication as an average set of photographs beautifully presented.

The level of attention paid to presentation of the final images can be subconsciously taken by the client to be a reflection of the overall attitude, professionalism and quality of the photographic work itself. A client who regularly receives good results from you, edited and presented in a consistently clean, clearly marked and efficient manner, is more likely to call you for that all-important next assignment than the photographer who presents his photographs in a disorderly array, stuffed into a scruffy resealed packet from the laboratory. The latter is inevitably viewed as indicative of a sloppy, uncaring attitude which the client is likely to mentally attach to the work, be that true or false.

Editing

Editing is primarily a selection procedure, but it should also be used as a constructive educating process. When faced with the sheet or roll of transparencies on a lightbox, exposure

comparisons and lighting ratio variants become clear, especially if you made a written record of exposure and lighting details at the time of the photography. The focus and colour accuracy should be checked, and if any consistent problems occur, a remedy must be worked out. Use a high quality magnifier to scrutinize the images to the full.

Editing a sheet of transparencies can be done in one of two ways. You can either edit out the significantly over- or underexposed frames, plus any that are damaged physically or visually, or you can edit the best transparencies for mounting prior to presentation.

Your choice of method will be determined by what you think your client will want to see. Most commonly with interior photographs, it is best to edit out any poor frames and present the client with a set of images of each shot, with slightly differing variations in the lighting ratios. This will give him or her the opportunity to select the preferred lighting ratio and precise exposure, without imposing your own personal preferences.

Some less experienced editors appreciate the photographer's advice on the most suitable transparency for reproduction. If this is the case, you can mark your preference with a small cross, using a chinagraph crayon, on the acetate sheet in which the transparencies are simply mounted by the laboratory. Chinagraph crayons are soft and waxy, and come in a variety of colours. They write easily on acetate without damaging the transparencies within, and their marks can be easily wiped off with a soft cloth, or even a finger, if no longer wanted. This method allows the editor also to view the unselected transparencies to check that you have chosen the most suitable ones.

In editing out the poor transparencies, we must physically cut out any that are clearly unacceptable. This will effectively reassure your client of your consistent results, and improve your presentation. In doing this, or at any time you are directly handling the transparencies or negatives, it is best to wear soft, lint-free cotton gloves to protect the films from finger marks. If you do have to handle them with bare hands, ensure that your hands are freshly washed and properly dried, and that you only ever handle them by the edges. Finger marks are difficult to remove from transparencies or negatives without causing further scratch damage, so handling films with bare hands should be avoided wherever possible.

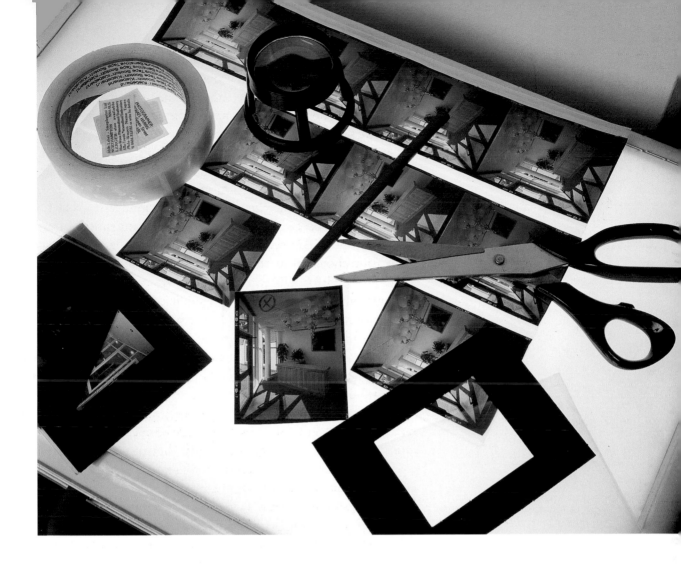

First, cut out any that are physically or visually damaged. Despite the excellent and consistent processing produced by commercial laboratories, small creases, scratches or chemical stains do damage the occasional frame from time to time (see the next section on 'Film damage' for details). The odd frame will also inevitably be shot either without the flash cable attached, or with a person unexpectedly walking through a door within your picture area during an exposure. This is what I mean by visual damage.

Next, cut out the significantly over- and underexposed frames. There might be a couple out of the 10 or 12 frames like this, but hopefully not more than that. Finally, you may wish to edit a further image for the purposes of your portfolio. Assuming your sheet of transparencies is possibly reduced to seven or eight frames from an original ten, there should be plenty of good images within the set to make this

Figure 10.1 The editing and mounting of transparencies should be done on a lightbox, using a freestanding magnifier for critical viewing. Mark up the sheet with a chinagraph crayon, then cut out the individual transparencies and mount them in black mask transparency sleeves, using permanent clear tape

possible. Such a practice can be easily overlooked or ignored at busy times, but once delivered to the client, you are unlikely to see those transparencies again.

If you choose to edit the best transparencies for mounting prior to presentation, or by marking the sheet of transparencies with a chinagraph crayon to advise the editor, you have to be very particular in your selection. Selecting transparencies for reproduction might sound simple, but it actually requires great care and consideration.

Use a lightbox, preferably with fluorescent tubes colour corrected to 5500 K, to enable you to view at least one full sheet of transparencies at a time. Even if just editing the transparencies for subsequent mounting, use a chinagraph crayon at this stage to mark selected transparencies prior to cutting them out. This will allow comparison of transparencies on different sheets if the pictures are to form a consistent set, before finally committing them to the scissors.

To the inexperienced eye, there is often a tendency to select an image that is bright and light. However, the lighter the transparency the weaker the colour saturation. Conversely, the darker the transparency, the richer the colour saturation which, obviously within limits, is better for reproduction (and certainly for duplication). It is impossible to enrich colours in a very light transparency (overexposed), but it is possible at the reproduction stage to boost the brightness of a darker transparency with richer colour saturation (underexposed). It is also possible to make a brighter duplicate transparency from a darker original, but not the other way round. Selecting the preferred lighting ratio variant should be based primarily on what looks the most appropriate on the final transparency, but also on your experienced knowledge of the preferences of your client.

Film damage

As mentioned in the previous section, film damage does occur from time to time. I am using the term 'film damage' to cover any physical damage to the final image, be that in the manufacture of the film, the taking of the photograph or, more commonly, at the processing stage. Its unpredictable occurrence is another good reason for shooting a full roll of film on each different subject to allow for the possibility of losing the odd frame to such damage.

The worst possible type of film damage that can occur is when the whole film is ruined, rendering all the images of a

particular subject unusable. This can happen as a result of a rare manufacturing fault; as a continuous fault at the time of exposure; or as a result of a film falling from its hanger during development at the processing stage.

Fortunately, manufacturing faults are very rare as all film batches are tested by the manufacturer prior to sale. In 20 years I have experienced only two, both by leading film manufacturers. One was a 35 mm roll of colour transparency film that was literally without emulsion apart from a couple of frames at either end. The middle 20 frames were a strip of completely clear acetate. The other was a 35 mm black-and-white film that was littered with small scratches over its full length. When such cases can be proved to be manufacturing faults, the major film manufacturers are sometimes willing to pay you compensation for having to repeat a job, at your current rate, beyond their legal liability just to replace the film.

Film damage that can occur at the time the photograph is taken includes 'fogging' (when the film is accidentally and unknowingly partially exposed when outside the camera) if

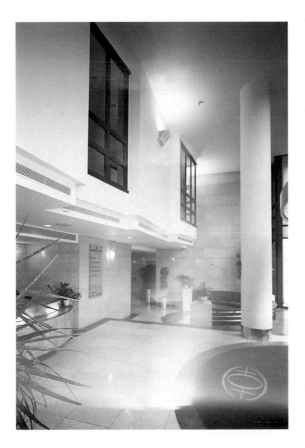

Figure 10.2 An example of film damage caused by 'fogging'

the film is loaded or unloaded in too bright conditions; any small light leaks within the camera; or more commonly, a hair or other obstruction trapped in the film plane of the film back, between the film and the incoming image.

To overcome the problem of fogging when loading or unloading the film from the camera, always make sure you do this away from direct sunlight. Also, with roll film, ensure that the backing paper is as tightly wrapped and sealed around the exposed film as possible. With due care, this is a rare problem.

A hair or other obstruction trapped in the film plane is more difficult to control, other than to keep all your camera equipment as clean and dust free as possible. This means regularly dusting off and cleaning lenses, the interior of the camera and especially the interior of the film backs. Needless to say, extreme care should be exercised in all such cleaning operations. The backing paper in a roll film prevents dirt from scratching the film on the pressure plate in the film back as it is wound on, but small pieces of dirt caught on the side of the film plane can lead to costly retouching bills.

Processing faults are more common than manufacturing faults, but usually less drastic unless, as already mentioned, the film actually falls from its hanger during the processing. Processing faults come in a variety of recognizable forms: small creases that render a small, black crescent-shaped mark on one frame of the transparency when processed; chemical stains, most often yellow, that damage only one or two frames; or small, white scratch marks which have occurred, for whatever reasons, while the emulsion was in its vulnerable, wet state. Over- or underdevelopment is another potential processing fault, and this can be readily checked visually by direct comparison of the pre-exposed manufacturer's numbering on the suspect film, with that on a previous correctly developed film. If the numbering appears weak, this would suggest underdevelopment; if it is very bright, heavy and woolly, overdevelopment.

The most fool-proof system a photographer can adopt to insure himself against the possibility of film damage is to shoot a few extra frames of each subject on a separate film, using a different film back. If the original films are undamaged, the spare film can be confidently thrown out without the expense of having it processed. This can be a small price to pay compared with the inconvenience, disruption, embarrassment and cost of reshooting should

any drastic damage occur. It can also provide you with a further source of images for your portfolio should you need them.

Mounting

Having selected the best transparencies for either your client or portfolio, and cut them out as individual images from their film strips, it is time to mount them prior to presentation or storage. Both editing and mounting are most easily and neatly performed on a lightbox. It enables you to have a clear view of the transparency for perfectly aligned mounting.

The most popular method for mounting transparencies, especially those larger than 35 mm, is to mount them in black mask transparency sleeves. The masks are made of folded black card with precision cut frames for the transparency size chosen. The mask is opened like a greeting card and the transparency aligned inside the mask. If, for any reason, the image on the film has been taken slightly off square, there is usually just enough room within the mask frame to twist the transparency round a fraction to make the final presented image appear perfectly squared off. The transparency is then taped in position along one side with a small piece of permanent clear tape. Permanent tape differs from regular adhesive tape in that the glue it uses never deteriorates into a potentially damaging sticky mess. It should readily peel off the transparency at any time in the future. The tape must be stuck only to the very edge of the black transparency frame

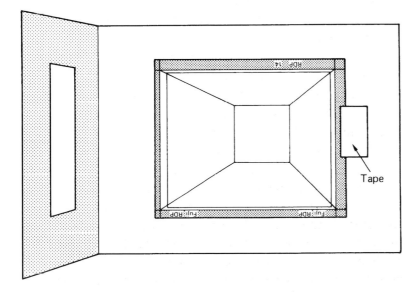

Tape

Figure 10.3 The black mask transparency sleeve. The transparency is taped in position along one side with a small piece of permanent clear tape, taking care not to cover any part of the actual image. The mask is then closed like a greeting card, the photographer's personal adhesive label stuck on the front, and the mounted transparency placed inside a protective acetate sleeve, open end first

PROFESSIONAL
INTERIOR
PHOTOGRAPHY

and should under no circumstances cover any part of the actual image. This will provide a quite sufficient anchor for the transparency and minimize interference with it.

The mask is then closed creating an attractive, black frame around the image. This enhances the whole appearance of the photograph. The photographer's personal adhesive label (with details of name, address and telephone number) can be stuck to this black frame. This should ensure that it never gets lost and also acts as a useful reference for the editor if he wants to publish the image with a credit alongside. The mask is then placed, open end first, inside a clear acetate protective sleeve, with a matt back to diffuse the light passing through it. This enables the mounted transparency to be viewed clearly both on a lightbox and when held up to any available light source. The matt back prevents any distraction from the possible view of the light source behind it, be that a window or domestic tungsten lamp.

Presentation to the client

The transparencies are now edited and mounted either in black mask transparency sleeves or in the clean acetate sheets from the laboratory. Both are perfectly acceptable ways of presenting images to clients. It may be necessary to mark the different images or sheets with reference numbers relating to typed details on a separate sheet of paper. It is certainly necessary to mark the envelope with details of the contents and to clearly print the client's name and address.

The envelope should always be new, of a size to match the contents, and card-backed to protect the transparencies or prints. It is useful to your client's receptionist if you place one of your personal adhesive labels on the reverse of the envelope as an indication of who sent the package. It is also courteous to include a compliments slip with the pictures. If the photographs are to be posted, or delivered by messenger, it is also sensible to ensure there is a 'Photographs – Do Not Bend' warning stamp on the front of the envelope. It should go without saying that all posted photographs should be sent first class, and by recorded delivery if you want proof of their receipt.

Portfolio

A portfolio is your own, very personal, advertisement to potential clients. Its purpose is to impress potential clients so much that they choose you for their future photographic

requirements. It must, therefore, be the best possible presentation of the best possible images you have taken in the area of interest of your potential client. It also helps if you take along a selection of publications in which those images have appeared, to give added credibility to your success and, therefore, suitability.

Your portfolio should be carefully created from your stored work back at base, each time tailoring it specifically to the likely requirements of that potential client. It is much better to show a few quality images in his or her likely area of speciality, than a vast range of all the photographs you like best from your full collection.

There are various methods of displaying your portfolio, and your choice will depend both on preference and budget. These range from an expensive briefcase lightbox to a simple plastic carrying case. The advantages of the briefcase lightbox are that it is both the smartest way to transport your transparencies and gives you the confidence that they will be properly displayed whether or not your potential client has a lightbox available. Again, it also helps convey an overall impression of quality and efficiency.

Within such a briefcase, or other carrying case of your choice, your transparencies should be mounted in black mask transparency sleeves either singly or in carefully selected groups. A3- or A4-sized black mask transparency sleeves are available for mounting a quantity of transparencies on a single sheet, typically between two and 12 for medium-format transparencies.

If you decide not to purchase a briefcase lightbox, and there is no lightbox available, transparencies can be adequately viewed by holding them up to a window. A small, inexpensive standby measure might be to carry a battery operated mini-lightbox with you, available with a screen size of 5 in × 4 in.

Published material should form the other part of your portfolio. This can either be presented from a smart folder or briefcase in its raw state as the brochure or magazine feature that it is, or can be selectively edited, mounted on black card and laminated. Lamination protects the material from becoming fingered, creased and scuffed, and keeps it looking its best for longest. The mounting on black card, an A4 size image on A3-size card for example, gives the material a feeling of selective importance, with the black framing giving the image more impact, just as the transparencies mounted in

black mask transparency sleeves. The laminates can be transported and presented from a smart art case. If you have no published work, do not be put off. High quality transparencies or prints can respectably stand alone.

It is also sensible to have a photographer's card with your name, address, telephone number and a selection of your best images to leave with the potential client as a permanent reminder of your work. A few printers specialize in this kind of work, so for the highest quality service and best advice it is best to go to one of these specialists. If such a card is beyond your budget, at least have some smart business cards printed.

Finally, because a portfolio presentation is about both your work and you as a photographer, your personal presentation and efficiency will also be under scrutiny. Dress smartly, at least casually smart, and be on time for your appointments. A scruffy appearance and arriving 10 minutes late for an appointment could undermine your presentation, however good your work.

Storage

The main prerequisites for archival storage are to store your photographic images in darkness and in acid-free materials, in such a way that they can be easily retrieved. Three elements are involved in this process: first, the best method and most stable materials for storing individual transparencies or negatives; second, the most practical and efficient system for filing these transparencies and negatives; and third, the most suitable storage container for the filed material.

By their very nature, transparencies and negatives have to be treated in different ways for the first two stages. Because individual transparencies can be readily identified on a lightbox, it is customary to mount the best one or two as described in the earlier section on 'Mounting', and store the remainder separately in case of possible future use. Commercially produced black mask transparency sleeves should be of reasonable archival quality for storage and protect the transparency from dust and scratches.

Negatives, however, be they colour or black-and-white, are best identified from viewing a contact print in a file, and then drawing out the relevant negative from its file by use of a corresponding reference number. The negatives themselves should be stored in negative bags: preferably A4 size with ring

binder holes for simple file storage. Such negative bags are made of acid-free translucent glazed paper and are divided up to hold a full film of individual negative strips in one sheet, from which the corresponding contact print is made.

All mounted transparencies and filed negatives should be captioned, dated and/or numbered depending on your personal choice of filing system. Negatives are probably simplest filed by number in separate files according to subject matter. Their corresponding contact prints can be filed in a similar way, with relevant captions and dates for reference.

Transparencies are also most efficiently filed by subject matter and number and, depending on the quantity of each subject, can be subdivided any number of times to keep each file to a manageable size. For example, a general commercial photographer may have a file for architecture, one for portraits, another for travel, etc. As he starts to specialize in architectural photography, he can split his architecture file in two: exteriors and interiors. As these shots build up, he can further subdivide his filing system. Both exteriors and interiors can be divided into commercial, residential and communal. If further divisions are necessary, exteriors can be broken down into traditional and modern categories; interiors into room types within the commercial, residential and communal categories. A system of cross-referencing may be important if individual images are subdivided away from others taken of the same building. This is where the numbering is important for transparencies. All divisions, subdivisions and numbering should be recorded in a separate file or on computer.

It may be more relevant to your personal requirements to file all shots of a particular building together, rather than to subdivide them into different categories. If this is the case, this can either be done numerically (perhaps by job number) or alphabetically, again with written details on file for quickest access.

Once you have worked out a suitable filing system, you must turn your attention to the problem of the physical storage of all your transparencies and negatives. As already mentioned, negatives can be filed in commercially produced negative files, kept in sequence on a shelf. They can alternatively be stored in metal-tray drawer cabinets, which are also very suitable for storing transparencies.

Transparencies can be mounted for filing in a standard metal filing cabinet, or housed in enclosed plastic trays within

a commercially designed transparency storage cabinet. Storage should not be in wooden or cardboard boxes in case acids within them start to deteriorate the emulsion. One final note of caution: keep all negatives and transparencies out of direct sunlight at all times and in darkness as much as possible. Try and avoid the frequent projection of transparencies, and if this is impossible either make duplicates for such purposes or scan them into digital form.

Digital storage

The concerns over storage of digital images are quite different to those of film. Image damage is less of a concern than choosing the appropriate file format and media for storing the images that will be compatible with the hardware and software employed by future users.

The higher the quality of the digital image, the larger the file size, and this can be massive when working with a high-end digital back producing 96 MB image files. Hard drives fill up and sooner or later image files will have to be stored on some form of high-capacity removable media such as the CD-R, with a large 650 MB capacity. The only practical way to store and transport image data between different computers, e.g., yours, the client's and the publisher's, is to choose a drive and removable media combination that is compatible with all concerned.

A variety of high-capacity removable media are available, including the popular CD-R already mentioned, which has the great advantage of being compatible with virtually all current computers. A whole portfolio can be stored on a CD-R for easy replication and mailing to potential clients. Other popular media include the Jaz and Zip disks with their respective drives, but they do require the end-user to have the appropriate drive to read the data. DVD-RAM drives are also available, with a vast 5 GB capacity. These are useful for backing up data: for storing all the latest files at the end of the day on an external medium to prevent the loss of data if the system crashes or disks get damaged.

Having decided *where* your images should be saved, you now have to decide *how* they should be stored. This is a question of choosing a file format and again there are various options depending on the likely future use of the images. Because image files are so large, it is sensible to compress images for storage in order to keep storage space to a minimum. There are two different types of image

Table 10.1 File formats. Different file formats are appropriate for different uses, as this table shows

File type	Data compression	Desktop publishing use	Internet use	Layers	Add text
Photoshop (.psd)	✗	✗	✗	✔	✔
GIF (.gif)	✔ (Lossless)	✗	✔	✗	✗
JPEG (.jpg)	✔ (Lossy)	✗	✔	✗	✔
Photoshop EPS (.eps)	✗	✔	✗	✗	✔
TIFF (.tif)	✔ (Lossless)	✔	✗	✗	✔
PNG (.png)	✔ (Lossless)	✗	✔	✗	✗

compression, known as 'lossless' and 'lossy'. Lossless compression squeezes large image files into smaller spaces by detecting sequences of similar coloured pixels. This reduces the need for a separate code for each pixel, and causes no loss of image quality. The most popular form of lossless compression is with TIFF files (Tagged Image File Format), making a saving of about a third of the original file size.

The second type, lossy compression, reduces image data by assigning a compromise colour value to a block of pixels, typically 9×9, rather than to each individual pixel. This causes an irretrievable loss of image quality, most noticeable in smooth gradient areas. JPEG files (Joint Photographer's Experts Group) are the most widely used lossy compression files. A sliding scale from 1 to 12 allows you to control the amount of compression used to save an image. The greater the compression, the more noticeable the effects of the process on that image. The strength of the compressed JPEG files lies in their ease and speed of transmission via e-mail, with a quality quite adequate for Web use. Images can be compressed and sent over conventional telephone lines with ease. TIFF files, on the other hand, are usually too large to send via e-mail and are more usually burnt onto a disk and delivered in the usual manual way.

Because TIFF files can be compressed without loss of image quality, it is this format that is most widely used for the archival storage of images. It is also the preferred format of most press houses.

Other formats include PSD (PhotoShop Document) and EPS (Encapsulated PostScript). PSD files allow an image to be separated into different parts onto transparent layers. Each layer can then be manipulated without affecting the rest of the image. When the image is viewed as a whole, all the layers appear merged and the picture looks flat. When working with layered images, other file format options are unavailable until the image has been flattened. EPS image files are designed for use in page layout programs such as QuarkXPress.

Choice of format, therefore, depends on anticipated end use. Files kept in a TIFF format offer the best combination of compression without loss of image quality. Compression can be turned on and off, and format changed at a later date, so storing images in this format offers the most flexibility for future use.

APPENDIX: PROFILES AND TECHNIQUES OF SOME MASTERS OF INTERIOR PHOTOGRAPHY

The master photographers featured in this Appendix – Brian Harrison, Andreas von Einsiedel, Derek Kendall and Peter Aprahamian – are all charming, positive and enthusiastic people, sharing a common passion with similar aims. They have each received deserved accolade for their personal styles of interior photography by their own tried and tested methods and techniques. All generously divulged specific details of their working practices for the purpose of this book, for no personal gain.

Perhaps not surprisingly, not one of them left school or college with the immediate desire or intention to be specifically an interior photographer. Each undertook other commercial work before discovering his passion or forte for interiors, and was often led to it by some happy coincidence rather than through his own conscious making. Common threads run through all the techniques in terms of similar cameras, lighting equipment and film choice, but beyond that the actual working methods of each photographer are very idiosyncratic.

Fine examples of the master photographers' outstanding work are included, along with quotes by them on how the shots were taken. All are worthy of unhurried contemplation and detailed analysis to appreciate their brilliance.

Brian Harrison

Brian Harrison, in his mid-40s, works for all the major interior magazines. His pictures are characterized by his original and imaginative lighting techniques which he has mastered through a highly varied working life in photography. He works as part of a journalist/photographer team with his wife Carolyn, who is both stylist and feature writer.

Profile and history

Yorkshire born and bred, Brian studied graphic art for three years at York Art School, which proved to be a useful foundation for his subsequent career in photography. It was at art school that he discovered his interest in photography and chose to concentrate on this as far as possible in his final two years, making the most of the then free use of photographic materials that art schools used to enjoy.

As luck would have it, Brian came straight out of art school and into a job as a trainee photographer for a news agency in York. He stayed there for three years, reaping wide experience in the harsh reality of press photography, supplying photographs for the national newspapers and also doing

Figure A.1 Brian Harrison

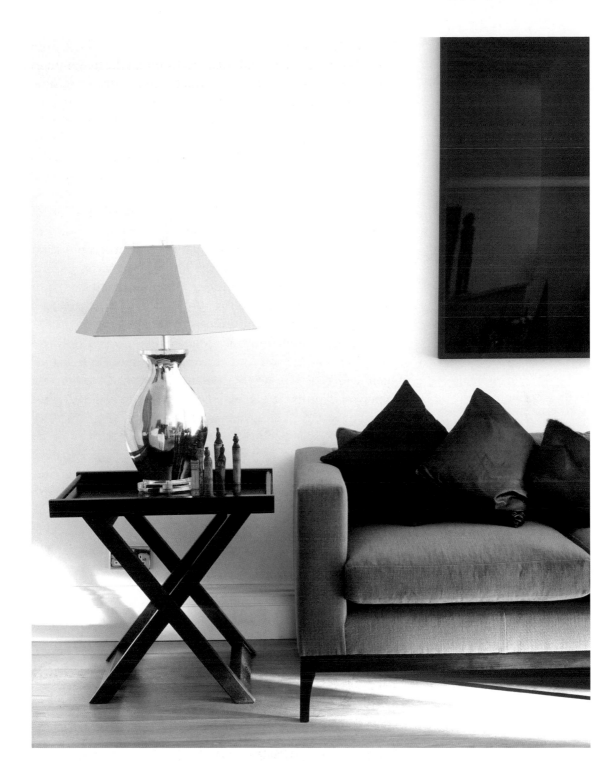

Figure A.2 Master interior photographer Brian Harrison: 'Wherever possible, and as a welcome relief from general room shots, it is good to find a graphic composition to photograph. Not only does it look dramatic, but it can quite often be chosen as a magazine front cover. This shot, taken in a North London house, has been used as a front cover for an Irish magazine and as a full page in three or four different publications. I used a mirror to achieve the cross lighting, bringing the sunshine from the window across the room. The fact that the furniture and accessories are all in varying shades of brown adds to the drama, as do the reflections in the picture and lamp-base.' (Photograph copyright of Brian Harrison)

some television camera work. This was an excellent journalistic grounding in learning how to go out and find stories, essential for his current interior work in which he and his wife search for interesting properties to photograph.

Brian left the news agency to go freelance. His contacts with journalists led him into the world of general commercial photography. He later joined a photographic agency in Bradford for four years where he found himself doing large-format studio work, mainly advertising and fashion.

It was while working on a job for the *Radio Times* that Brian met journalist Judi Goodwin, who introduced him to the world of interior photography for national magazines. He then had a spell running a large studio with his wife Carolyn, where he was able to continue his fashion and advertising work. He also started to photograph room sets for the catalogues of such furniture companies as Gratton and Great Universal. However, Brian found this work uninspiring and, as he was doing more and more location work for magazines, he decided to give up the studio when the lease came up for renewal. By this time, Carolyn had given up running a foreign language agency and completed a course in journalism, so the two of them decided to specialize in location interior work. Working together as a photographer/writer team has been a very successful combination. Having researched suitable houses for magazine work and built up a relationship, often a friendship, with the owners, they now have a bank of suitable locations to hire for their commercial work, which is mainly photographing furniture, fabrics and kitchens.

Practice

Brian and Carolyn work from their home in West Yorkshire, though inevitably much of their time is spent travelling both around this country and in Europe where they hope to expand their operations in the future. Their travel tends to be financed by commissions, which afford them the opportunity for researching future stories. Brian photographs potential locations with his digital Nikon D1 using available light. He finds this ideal for e-mailing the images to the magazine editors to secure the commissions.

Being a self-generative team, the Harrisons find that so far they have not required the services of an agent to find them work. Similarly, Brian does not work with an assistant. Unlike the days when he worked in a studio and an assistant was an essential member of the team, working on location is

a different story. He finds that two people working in someone's private home can be treated as guests, while three people (if he were to take an assistant) could become an intrusion. He always works with a stylist, usually his wife Carolyn. She can be working ahead of him preparing the next shot, thereby making the most of the limited time available. As for photo libraries, Brian markets his images through Red Cover in West London, and uses Rex Features for his old press shots.

Equipment and technique

Brian shoots most of his magazine work on a Fuji GX-680 Mk III, which gives him the flexibility of limited shift movements with all lenses. He carries a range of lenses from 50 mm to 360 mm and also carries a Nikon F3 for 35 mm work. Having sold his Sinar 5 in × 4 in view camera in order to purchase better lighting equipment, he finds it more efficient to hire large-format cameras when required, than to have so much capital tied up in a camera that he finds he now rarely uses.

The flash lighting he uses is a Broncolor power-pack system, consisting of two normal heads, one high-output head through which he can generate an 8000 J discharge using two power packs, and a focusing head for which he makes his own original cardboard gobos to create more or less whatever lighting effect he chooses. He also carries a 2 kW blonde tungsten light, which he uses outside with a blue gel to create the effect of sunshine through the window on rainy days. He prefers to use flash to create the effect of sunshine on cloudy days as this enables him to cut out as much of the available light as he likes, but finds the tungsten blonde more resilient to adverse weather conditions.

Brian also carries two other vital pieces of equipment that he would not be without. First is a heavy-duty stand, which he assures me is so robust it will withstand any wind and weather conditions and needs to be cranked up and down to achieve its massive 4-m height. The stand is used outside to support either the tungsten blonde or a flash head. It can also be used to support Brian's second piece of vital equipment: a small collection of mirrors that he uses to redirect the angle of the sun into the interior for the most natural appearance of a sunshine effect that it is possible to achieve. He can attach a 30-cm square mirror to his stand using Manfrotto clamps. The only problem with this

Figure A.3 Master interior photographer Brian Harrison: 'This photograph was taken with a 180 mm lens to pull all the elements together. As it was quite a dark room with overhanging trees just outside the window, there was no direct sunlight. I therefore needed to create my own. This was achieved by using a mirror placed on a stand about 10 metres away from the house, reflecting the sunlight into the room onto the objects at the focal point of the shot. I then needed to 'clean up' the light in the rest of the room. This was done by using a soft-box on a light, set to $3\frac{1}{2}$ stops less than the available, together with a very subtle light bouncing into the white ceiling. This softens the shadows from the soft-box even more. Finally, opening the window slightly creates the feel of a nice summer breeze coming into the warm sunlit room.' (Photograph copyright of Brian Harrison)

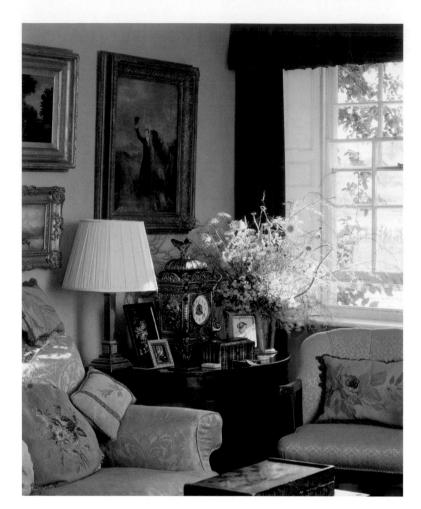

technique, however, is the sheer speed with which the sun moves. By the time the Polaroid has been shot and processed, the mirror needs to be re-angled on top of its 4-m stand before shooting the actual transparency film. At present Brian does this manually, but is hoping to develop a remote control system for this purpose at some point in the future!

On his interior shoots the principle that Brian works with is to create the effect of sunshine coming through the window (be it real, reflected or totally artificial). Such a crossover of light from outside to inside produces the most natural and convincing appearance on film. If flash is used for this purpose, he can dictate the amount of available light he wants to include, depending on whether or not he wants to see the view out of the window. The light inside the interior is supplemented by fill-in flash fired through a soft-box, with an output 3–4 stops less than the ambient light reading.

Brian shuns the use of umbrellas for interior fill-in as he finds they cause light to spill over into areas that do not require it. Soft-boxes are more directional and therefore more controllable. Brian uses a minimum number of heads for this fill-in, preferably only one. Where space is restricted, he bounces direct flash off the ceiling instead.

With regard to tungsten room lights, Brian keeps them switched off where possible, allowing the daylight (or artificial sunlight) to be the dominant lighting source. Where it is important to have a table lamp glowing in the picture, for example, he usually connects it up to a switch behind the camera so he can switch it off approximately a quarter of a second into the exposure. This creates the effect of a glowing light without 'burning out' the lamp and discolouring the ambient light.

Brian tries not to shoot general room shots at apertures wider than $f/11$, and usually at exposures of between 1 and 8 seconds. His preferred film choice is Kodak EPP 100, a daylight-balanced colour transparency film. He uses this in conjunction with Polaroid Polacolor 100 which he finds gives a better exposure guide if left to process for a couple of minutes instead of the recommended 90 seconds. Because the tolerances of Polaroid instant-print materials have been improved so much over the years to cope with extremes of over- and underexposure, Brian finds that it has actually made it harder to use as an accurate exposure guide. However, he still finds it reasonably accurate even at long exposures of 8 seconds, despite the fact that the colours shift towards green. To economize on the high cost of Polaroids, he uses his digital Nikon D1 linked to a laptop computer to establish the basic set-up and lighting, and just shoots one Polaroid shot as a final confirmation before committing the image to film.

Brian scans all his transparencies prior to submitting them to the magazines. This is both a security measure and enables him to sell his images on CD to magazines abroad. It also allows him to produce his own colour prints, from commercial shoots, on his Kodak dye-sublimation printer.

Advice

Brian's words of advice for people interested in interior photography are primarily to talk to the magazines to find out what they are currently looking for, as their photographic styles and preferences change continuously. On the technical

front, keep the camera back vertical to avoid diverging verticals (unless done deliberately to create an effect!). Be especially careful to avoid any flash reflections in windows, pictures and picture frames. Finally, do not kill the atmosphere of the interior by overlighting it.

Brian's motivation derives from his early press days: the love of the chase. These days it is the chase to find the best possible house. He is passionate about interior photography, enjoying juggling and balancing all the variables involved: all the different people, the different rooms and the different lighting, including, of course, the unpredictable natural light.

Andreas von Einsiedel

Andreas is one of today's most talented and best-known interior photographers, his work appearing regularly in the full range of interior magazines. He works with great sensitivity and a deep understanding of the nature of natural light in an interior, and has the ability and experience to judge the intensity of light in a room visually,

Figure A.4 Andreas von Einsiedel

without the use of a light meter, experimenting on Polaroid instant-print film to assess his judgement. He considers himself more a traditional than modern photographer, preferring to produce transparencies that are perfect technically than following the out-of-focus/overexposed style of some modern magazines.

He has illustrated numerous books and also does a lot of work for the National Trust, enjoying being locked away in fine houses for a week at a time and left to his own devices. The Trust give him a list of what they want and then leave it up to him to interpret and light it.

Profile and history

Andreas was brought up in Germany in the 1960s, with a clear ambition to be a photographer from the age of 15. The lure of London's youth culture drew Andreas in the mid-1970s to the (then) Polytechnic of Central London in the heart of the West End to study for a BA in Photographic Arts. After graduating he returned to Germany where he worked as an assistant with a film company that made TV commercials, before moving on to work as an assistant to a leading German commercial photographer in Hamburg. By the end of 1979 he decided to return to London where he found a job as assistant to car photographer, Norman Gold.

The time spent with Norman Gold enabled Andreas to build up a still-life portfolio as the basis for going freelance in 1981, at the age of 28. He received plenty of compliments for his work when touting his portfolio around the advertising agencies of London, which he found a very positive experience. This stimulated the start of a slow but steady flow of freelance commissions. Coincidentally, it was at about the same time that *The World of Interiors* magazine was launched amidst a massive expansion of the interior magazine market following the recession of the early 1980s. Fortunately, Andreas knew several people with fine houses so took the opportunity to photograph them speculatively in order to offer them as features for *House and Garden* magazine. *House and Garden* liked his work and Andreas found interior photography more appealing than advertising work, though continued to do both. The major turning point for him really came in the mid-1980s when he found that the magazines started commissioning him for stories, as well as taking his speculative features.

Practice

Andreas works from a shared studio in Clerkenwell, London, though the majority of his photography is location work. He does not have an agent and syndicates his work around the world both by himself or through the National Trust, which generates substantial further fees. He employs a full-time assistant and always works with a stylist, often the writer of the feature.

Equipment and technique

Andreas shoots 90 per cent of his interiors on a Hasselblad, either the 500 C/M or the 500 C/X, with a series of lenses from 37 mm to 180 mm. The remaining 10 per cent he shoots on a 6 cm × 7 cm Linhof Technikardan view camera, with lenses from 47 mm to 180 mm. All his Linhof lenses are fitted with Prontor Professional shutters, which are designed for multiple exposures without having to reset the shutter between exposures.

In terms of photographic lighting, Andreas uses a set of Elinchrom compact flash heads for most of his work, with their advantage of being lightweight and portable. Andreas likes to use long exposures, usually broken down into small multiple exposures, preferring to build up the flash output slowly. This allows him to fine tune the lighting with greater precision than is possible by bracketing in half stops on the lens. For example, if he is using an eight-shot multiple exposure with eight flashes, one flash less would represent $\frac{1}{4}$ stop less flash in terms of exposure, and one flash more would add $\frac{1}{8}$ stop to the overall flash output. The main (yet unusual) problem that Andreas finds is that the flash packs are scarcely weak enough for this technique.

Andreas prefers to use soft-boxes for fill-in lighting, though he does use umbrellas on occasions. He finds that soft-boxes placed in front of the windows can also be useful on very dark, grey days to mimic the effect of daylight. He will also use a honeycomb grid attached to a flash head beside the soft-box to throw concentrated light on specific small dark areas in the interior, when necessary. His other essential 'lighting' equipment consists of several 1.25 m × 1 m white polyboards which he clips to stands to use either as fill-in reflectors or conversely for cutting light out of the subject area. More and more he prefers to use these reflector boards than flash for fill-in lighting, especially for overseas work when lighting equipment has to be kept to a minimum.

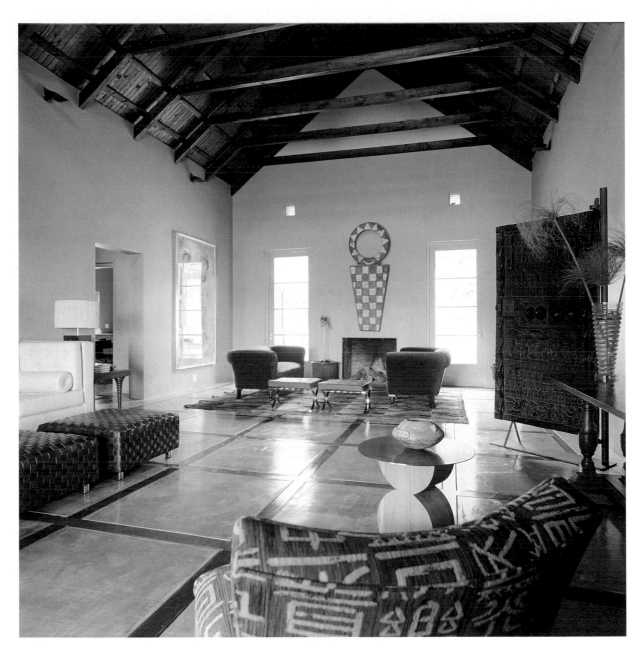

Figure A.5 Master interior photographer Andreas von Einsiedel: 'The farmhouse of Jaime Gubbins, Capetown, South Africa, photographed on Kodak EPP, with available light only. The images which appeal to me in interior magazines are invariably shot with available light only. Gentle fill-in is sometimes used to knock down contrast, but you have to look very carefully to notice this. When not relying on additional lighting, one learns to 'manage' daylight with the use of filters, mainly mild CC magentas to compensate for green casts, and light balancing 82 filters when shooting on tungsten film. Big white cardboard reflectors (1 m × 1.25 m) have become indispensable companions'. This image, shot with available light only, makes an interesting contrast with his image in Figure A.6 which was shot with flash lighting only. (Photograph copyright of Andreas von Einsiedel)

Two other vital pieces of equipment that Andreas would never be without are a colour meter and a spot meter. With the colour meter he finds that in 75 per cent of the interiors he photographs he gets a green reading from the daylight in the room. A 025 Magenta filter, the weakest available, subtly corrects this imbalance. Furthermore, he finds that interiors in the country or those surrounded by a lot of greenery are likely to need a 05 Magenta correction. Despite the fact that by and large he estimates exposures and apertures from experience, Andreas does use a spot meter to monitor the varying strength of the daylight in the room.

Andreas relies heavily on Polaroid instant-print film, especially the black-and-white Polapan Pro 100 which he finds an excellent exposure guide. He always shoots the first Polaroid without any extra lighting in order to see what is going on in the image. He then shoots further black-and-white Polaroids as he builds up the lighting in order to

Figure A.6 Master interior photographer Andreas von Einsiedel: 'This is a simple little interior shot which was taken in the entrance hall of a small cottage in the South of France. It was the last shot of the day and already dark outside. The picture had to look as if it was shot in daylight as all the others were. A big soft-box was placed outside the widow facing the camera straight on. A second smaller lightbox was placed in the doorway, fairly low, to give the main light on the table and objects.' (Photograph copyright of Andreas von Einsiedel)

ascertain precisely the effect of each additional light. Finally, he occasionally shoots a colour Polaroid print prior to shooting the transparency film itself. The 'unbeatable' transparency film stock that Andreas favours is Kodak EPP, a daylight-balanced film rated at ISO 100. He considers this the best all-round film, with relatively low contrast, insignificant reciprocity failure even at exposures of 2 or 3 minutes, and one that copes well in conditions of mixed lighting. He also uses Kodak ElOOSW for its extra warmth, and Kodak EPY which he finds a good film when pushed one stop. He tends on average to shoot a roll per interior shot, and takes one day to shoot a full feature.

Andreas has recently been experimenting with colour negative film, scanning the negative image into digital form. In terms of precise exposure, negative film is much more forgiving than transparency film, so shooting only two frames, as opposed to the ten he shoots on transparency, could lead to significant economies. However, he finds that magazines are not yet ready to take digital files from photographers. On a purely practical level, he sees that collective editorial decisions are more easily made around a lightbox than off a computer screen, which is a more private experience. To a trained eye, transparencies on a lightbox are both quicker and easier to assess than a series of images on a screen.

All Andreas' equipment is completely manual, affording him total control over whatever photographic situation confronts him. His subtle use of the spot meter also gives him mastery, to a large extent, over the unpredictable natural light. His favourite weather conditions are bright overcast days which yield a lovely soft light for interior photography. Andreas carries a huge amount of equipment with him to every shoot, filling a large estate car. His ideal day is to carry all this equipment . . . and use none of it!

Advice

The simplest, and yet possibly the most profound, piece of advice Andreas would give photographers starting in this field is to try and photograph only good interiors: those that are stylish, with ideas, that have taste. This makes the job so much easier that inevitably the results are going to have a head start. Always look for views through the building: anything that allows a room to look different or more interesting, such as shooting through windows and doors, works well.

Finally, Andreas never loses sight of the fact that it is a business machine that he is running which requires constant attention in order to secure future commissions in an ever more competitive market place.

Derek Kendall

As senior photographer at English Heritage, Derek Kendall has been responsible for photographing some of the finest historical interiors in Greater London, many of which remain hidden from the public eye. These include the City of London churches, the Palace of Westminster, St James's Palace and Clarence House, to name but a few. His photographs are used for English Heritage books, leaflets and public archives.

Derek's current project is to photograph 52 West End theatres: vast spaces that demand lots of subtle lighting. His

Figure A.7 Derek Kendall

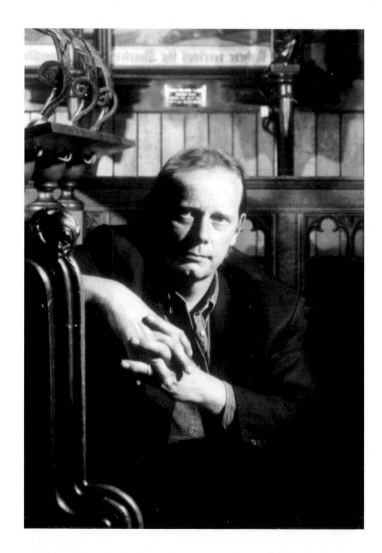

work, along with that of his colleagues, provides a fine historical reference both for now and the future, and as such must stand the test of time more than the commercial work of most other interior photographers.

Profile and history

Derek has worked for over 30 years in the photographic industry, though not all of it as a photographer. After leaving school in 1970, he worked for five years at Ilford Films, carrying out sensitometric and physical analysis of photographic glass plates. Samples of these glass plates, ranging in size from 60 in × 40 in (used by Ordnance Survey for contact-printing their maps) to 2 in × 2 in glass lantern slides, had to be processed to check for any physical or chemical manufacturing faults. During this time he also studied for a City & Guilds qualification in General Photography, so when Ilford Films terminated production of most glass-based products in 1975, he was prepared for a shift in employment.

He took up a job with what was then the Royal Commission on the Historical Monuments of England (which later merged with English Heritage), as a monochrome printer. Working from their collection of over 10 million negatives, Derek became filled with admiration for those early pioneering photographers who had to carry glass, chemicals, tents and huge wooden cameras. He loved the magic of the darkroom and the science of photography and, by 1980, became responsible for the introduction of colour processing and printing systems to the Royal Commission.

Several trips out with their location photographers to document listed buildings prior to alteration or demolition finally whetted Derek's appetite to become a photographer himself. Since 1986 he has been responsible for documenting buildings and structures of all descriptions, dates and uses in the Greater London area, and has illustrated numerous books. A 10-year project for the Survey of London, depicting the changes in Poplar and the Isle of Dogs, resulted in a two-volume set on the history of the area, and also a more affordable book: *The Making of Modern Docklands*. During this time he was awarded Associateship of the British Institute of Professional Photographers.

Equipment and technique

Derek uses a wide variety of equipment for his interior work. Most of his church shots were taken with a 5 × 4 Cambo SF,

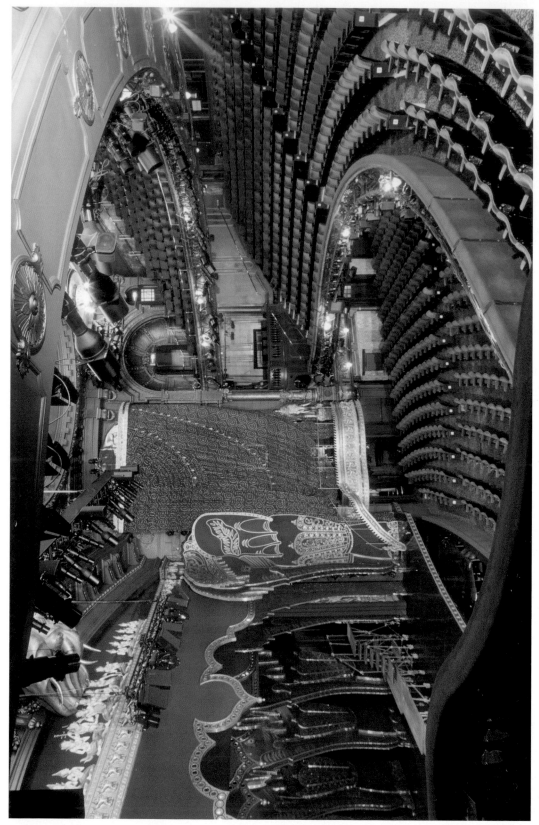

Figure A.8 Master interior photographer Derek Kendall: 'This is a view from the Royal Circle level across the auditorium at the London Palladium. It was shot with a Fuji GSX-680 III camera, with a 50 mm lens, on Fuji NPL 160 Tungsten colour negative film. The lighting was with 4 Bowens redheads with barn-doors. They were placed individually at each of the three levels (the spot on the right is actually a house-light), and one was put on the stage to light up the seats. A Bowens Esprit, using only its tungsten modelling lamps is off-camera to the right, and another is on the stage lighting the set.' (Photograph copyright of English Heritage/Derek Kendall)

and he is currently using a Fuji GS 680 III roll film camera for the theatre project. The roll film camera offers him greater flexibility and speed, combined with limited camera movements. He also uses a selection of Pentax and Nikon 35 mm cameras to produce colour slides for the purpose of lecturing.

For lighting, Derek mainly uses Bowens Esprit 1500 flash units (up to six at a time) and, for tungsten lighting, Bowens redheads. He also uses hand torches for painting with light, and even a cigarette lighter on occasion! For work in remote, large-scale interiors without a mains power supply, Derek uses traditional flashbulbs. These are triggered by two PP3 batteries and fired through a Bowens flash system. These flashbulbs are made by Meggaflash Technologies in Ireland, and though scarcely commonplace in most photographic retailers, can be purchased over the Internet (http://www.meggaflash.com).

Photographing theatres takes a huge amount of lighting. There is, of course, no natural daylight, so Derek has to introduce up to 90 per cent of the light. This is usually tungsten, from multiple areas, which has to be balanced with the house lights.

Derek's favoured films are Ilford HP5 for monochrome work, and Fuji NPL 160 tungsten for colour prints. Both films have excellent latitude and as such are very forgiving in terms of the extreme demands made of them in this type of work. He tends to use black-and-white for the structural recording of buildings, and often both colour and black-and-white for more decorative interiors.

The English Heritage photographers remain committed to capturing all their images on film, and scanning them into digital form when required. With a purpose-built archive in Swindon for storing negative film, they find the combination of shooting on film and digitizing afterwards gives them the best of both worlds, and the greatest number of options for future uses.

Advice

Derek's passion for this type of work comes from visiting often-familiar places and peeling away the veneer to look into the darker places where most people do not go. That is where you understand how things are built and created, and you meet the most interesting characters. His job is to illustrate that photographic narrative for others to consume.

Figure A.9 Master interior photographer Derek Kendall: 'This is a shot of the drum and shaft mechanisms, dating from around 1900, on the grid above the stage at the Comedy Theatre in London. Again this was taken with the Fuji GSX-680 III with a 50 mm lens, on Fuji NPL Tungsten colour negative film. The image was captured using the available tungsten light only, with a 2 minute exposure.' (Photograph copyright of English Heritage/Derek Kendall)

The most important piece of advice he has for other photographers is to see and understand the light that already exists in an interior, and to think how you can work with it. Make sure you get the balance right between available light and supplementary light so that you do not destroy the atmosphere. You are often dealing with the work of great architects who had a design in mind for how the building should look. To fill it with flash or other unnatural light sources would be to destroy their intention. Try and use one type of light – tungsten, fluorescent or daylight – rather than mixing sources.

Derek's final piece of advice is to always approach a building as if for the first time to avoid any preconceptions. Many of the historical interiors that he shoots have been photographed time and again. If you look at what everyone else has done, you can have one of two reactions: you either want to avoid repeating what has been done before or you want to do it better.

Peter Aprahamian

Widely acknowledged as one of the country's leading interior photographers, in his late 30s and with two books under his belt, Peter Aprahamian has already achieved more than many photographers achieve in a lifetime. Pick up any of the top interior magazines and his name is likely to be found among the credits. His work is perfectionist without being clinical, and always atmospheric, stretching film to the limits of its exposure range in order its realize its full potential.

Profile and history

Born in New York, Peter grew up in Northern Ireland where he developed a fascination for exploring derelict buildings. It was this fascination, combined with a passion for photography that he discovered while travelling the world after leaving school, that led to his first exhibition. While studying Philosophy at Bristol University, Peter found himself vehemently photographing derelict interiors around the city. His results were exhibited at the local Arnolfini Gallery.

Figure A.10 Peter Aprahamian

After graduating with an Honours degree, Peter worked for an advertising agency in Bristol and as a rep. for a couple of photographers in London (which he has found useful experience for his own self-promotion). However, he was still unclear as to the precise direction he wanted to go. So started his two years of informal photographic training as an assistant to several still-life and fashion photographers. This period enabled him both to afford the purchase of a 5 in × 4 in camera and a flash system of his own, and to build up a reputable portfolio as a still-life photographer.

Peter's portfolio and earlier marketing skills enabled him to pick up work as a still-life photographer. His big break, however, came almost by accident. He was asked to undertake a reshoot of some fabrics at a hotel for *Traditional Interior Decoration* magazine. The boyfriend of the journalist writing the feature was himself writing a book about the hotel at the time: a young architectural historian by the name of Joe Friedman. It just so happened that Joe's next project was to write the text for a pictorial book on a hundred of London's finest period interiors and he was looking for a suitable photographer to capture the detail and atmosphere of these interiors on film for the book. A trip to visit the publishers, Phaidon Press, secured the commission. After nine months of hard work, largely undertaken with a 5 in × 4 in camera and heavy power-pack flash system, the result *Inside London: a guide to London's period interiors* (Phaidon Press, 1988) was born to high acclaim.

Peter now found that magazines such as *The World of Interiors* were contacting him with commissions, alongside his own efforts to market himself as an interior photographer. Commissions followed commissions from all the top interior magazines, and that is where Peter finds himself today, with a second book *Inside Barcelona* also under his belt. *Inside Barcelona* (Phaidon Press, 1992), written by Catalan architect Josep M. Botey, was a useful commission filling a three-month slot during the height of the recession. The intensity of this work, some of Peter's proudest to date, sometimes involved shooting four or five different locations in a day.

Having shunned the very notion of a nine-to-five lifestyle at an early age, Peter loves the freedom afforded by being a successful freelance. His motivation comes from his ability to pay the bills by doing what he enjoys most in life. He advocates a policy of self-promotion and does not employ the services of an agent.

Practice

Peter's base is his North London home where he also has a studio for portraits and still-life work. He sometimes takes a freelance assistant with him on interior shoots, especially when he knows there will be a lot of equipment to carry around, furniture to be rearranged and cars to be shunted from meter to meter. Peter finds an assistant useful for bouncing ideas off and also for entertaining the client, in order to afford some private space to concentrate on the job in hand.

The amount of styling of interiors that Peter has to do varies from magazine to magazine. Often a magazine will provide a stylist, especially where major rearrangement is demanded. Otherwise he does it himself, a skill acquired through years of experience.

With regard to stock photographs, Elizabeth Whiting Associates markets some of his images, while Peter markets most of his interiors through his own stock library.

Equipment and technique

Peter uses two cameras for his interior work: a Hasselblad 500C/M with a series of lenses from 50 mm to 250 mm for most interior magazine work; and an Arca Swiss 5 in × 4 in view camera, with lenses ranging from 90 mm to 250 mm, for big interiors where the need for camera movements is essential. For regular domestic interiors, the 6 cm × 6 cm format Hasselblad, carefully levelled for retaining perfect verticals in the image, is a joy to use for sheer speed, ease of use and modest film and processing costs.

The transparency film stock Peter favours, for both the Hasselblad and the Arca Swiss, is Fuji Provia 100 and Kodak Ektachrome E1OOS. Both emulsions satisfy his exacting demands.

As for lighting, on big projects such as his books where he is faced with lighting large interiors, Peter uses an Alfa 5K power pack with three flash heads. For the rest of his work he uses two Bowens silver monolites. His basic technique is to use ambient daylight as the dominant source of illumination, with flash bounced off white umbrellas to act as a soft fill-in, fired to produce an output 2–3 stops lower than the aperture for the ambient light. This maximizes the natural atmospheric appearance of the interior, while just retaining visible detail in the shadow areas. Room lights are usually switched off, even on overcast days, as 'cooler' shots are currently

Figure A.11 Master interior photographer Peter Aprahamian: 'I was commissioned by *The World of Interiors* to shoot a completely faked reconstruction of a Roman Bath, built under the garden of a London mews house. We decided to liven up the picture with some models and I wanted the picture to look as natural as possible rather than to be artificially lit by the hidden tungsten spots about the ceiling. There was some natural light filtering through the thick glass blocks in the ceiling but nowhere near enough to freeze the kids in action and retain the quality of medium format on ISO 100 film. So I blasted filtered flash through the ceiling to achieve a hazy, sunny day feel to the room and to give me enough speed to freeze the kids and splashes. It was also a lot of fun figuring out a way of supporting my camera at the deep end of the pool!' (Photograph copyright of *The World of Interiors*/Peter Aprahamian)

morc in vogue than 'warm' shots. He uses natural daylight wherever possible, without filtration, to illuminate the interiors, even preferring the cool, silvery light of a dull day to the rich, warm light when the sun is shining. Apart from using flash for fill-in lighting, on a dull day he sometimes uses it in front of a window to supplement the daylight.

When he wants to emulate the effect of direct sunshine, Peter uses a very powerful direct flash, with a warming gel, outside the window. He never uses tungsten lighting for this purpose, and rarely uses tungsten lighting at all. Occasionally when using tungsten-balanced film, in an interior wholly illuminated by tungsten room lights, he will use the modelling lamps on the flash heads for fill-in lighting.

Typical exposures are 1 second for magazine work on the Hasselblad, and up to 4 seconds on the 5 in × 4 in Arca Swiss. These exposures avoid any problem of reciprocity failure. He brackets both film sizes: with the 5 in × 4 in he tends to shoot two sheets at what he calculates to be perfect exposure, one at a half-stop over and one at a half-stop under. He processes one of the 'perfectly exposed' transparencies before adjusting the process for the rest as necessary. Ambient light is measured using the metering system in a Leica fitted with a 35 mm lens. This gives Peter a broad overview of the ambient lighting, yielding reliable results.

For most of his work, Peter shoots colour Polaroid instant-print film to check for layout and styling, and because clients prefer to see a colour image. For preference, however, and as a better guide for exposure, Peter would choose black-and-white Polaroid film though this is usually impractical for the above reasons.

Advice

When asked if he had any tips for photographers starting in this field, Peter said the most important piece of advice would be that if you don't have a camera with movements, always use a spirit level to ensure the camera is perfectly level. There is nothing worse than an image of an interior with converging or diverging verticals that has been squared-up with the line of the page on one side and let go at an uncomfortable angle on the other side.

Two other words of advice: try not to over flash the interior, as this destroys the subtle atmosphere of the natural ambient light; and avoid leaving room lights on when there is sunshinc streaming into thc room.

BIBLIOGRAPHY

Andrews, Philip (2000) *The Digital Photography Manual*, Carlton Books Ltd.

Buchanan, Terry (1984) *Photographing Historic Buildings*, Her Majesty's Stationery Office.

Daly, Tim (2000) *Digital Photography Handbook*, Quintet Publishing Ltd.

De Sausmarez, Maurice (1983) *Basic Design: the dynamics of visual form*, The Herbert Press Ltd.

Elwall, Robert (1994) *Photography Takes Command: the camera and British architecture 1890–1939*, RIBA Heinz Gallery.

Freeman, Michael (1981) *The Manual of Indoor Photography*, Macdonald.

Freeman, Michael (1990) *Collins Photography Workshop: film*, William Collins Sons & Co. Ltd.

Freeman, Michael (1990) *Collins Photography Workshop: light*, William Collins Sons & Co. Ltd.

Gore, Alan and Gore, Ann (1991) *The History of English Interiors*, Phaidon Press Ltd.

Haigh, Geraldine (November, 2001) 'Creative interiors: life on the inside', *Professional Photographer*, Market Link Publishing.

Hawkins, Andrew and Avon, Dennis (1984) *Photography: the guide to technique*, Blandford Publishing Ltd.

Lander, Hugh and Rauter, Peter (1989) *English Cottage Interiors*, Weidenfeld and Nicolson Ltd.

Langford, Michael (2000) *Basic Photography*, Seventh edition, Focal Press.

Langford, Michael (1998) *Advanced Photography*, Sixth edition, Focal Press.

McGrath, Norman (1993) *Photographing Buildings Inside and Out*, Second edition, Whitney Library of Design (out of print).

Pinkard, Bruce (1985) *Indoor Photography*, B.T. Batsford Ltd.

Smith, Ray (1995) *An Introduction to Perspective*, Dorling Kindersley Ltd.

Thornton, Peter (1984) *Authentic Decor, The Domestic Interior 1620–1920*, George Weidenfeld and Nicolson Ltd.

Westermann, Mariet (1996) *The Art of the Dutch Republic 1585–1718*, George Weidenfeld and Nicolson Ltd.

INDEX

Other books from the Professional Photography series ...

Professional Architectural Photography (3rd edition)
Michael Harris

In this highly visual, full colour text Michael Harris shares his professional secrets and demonstrates how to achieve top quality architectural images.

This third edition provides increased coverage of the revolution in digital photography, which is forcing all photographers to review their practices. The pros and cons of these developments are assessed through a comparison of the film and digital mediums and the highly debated variances in their quality and cost.

Michael Harris is a freelance photographer specializing in architectural and interior photography. His work covers a wide spectrum from industrial and commercial, to residential photography.

2001 • 208pp • full colour throughout • 246 x 189mm • paperback
ISBN 0 240 51672 9

For more details visit www.focalpress.com

*To order your copy call +44 (0)1865 888180 (UK) or +1 800 545 2522 (USA)
or visit the Focal Press website: www.focalpress.com*

Professional Press, Editorial and PR Photography
Jon Tarrant

Editorial, press and PR Photographers need to be able to take a range of interesting and informative photographs. Success requires not just individual flair and skill, but an ability to market those talents in order to win space in publications. This book is packed with hints, tips and first-hand advice on the day-to-day running of a business, the equipment you need and how to organise your finances. Advice on the best way to present your portfolio and how to deal with clients and work to a brief is also given.

Jon was previously a freelance press/editorial photographer and has worked on location and in studios for national newspapers, trade publications and multi-national companies. Once the Editor of HotShoe International and Professional Photographer magazines, he is now the Editor of The British Journal of Photography.

1998 • 192pp • full colour throughout • 246 x 189mm • paperback
ISBN 0 240 51520 X

For more details visit www.focalpress.com

*To order your copy call +44 (0)1865 888180 (UK) or +1 800 545 2522 (USA)
or visit the Focal Press website: www.focalpress.com*

Professional Nature Photography
Nigel Hicks

Based on the author's own experiences of running a successful nature photography business, this offers a unique insight into the essential tools and techniques: from the equipment you need, to researching and finding new clients, negotiating contracts, managing finance, working to a brief and an understanding of professional ethics. It also includes an overview of specialist skills, such as how to read difficult lighting conditions, shooting from a hide, stalking animals, photographing captive animals, photographing plants and underwater photography.

Nigel Hicks ABIPP, FRGS has a PhD in Biology and runs a successful nature photography business. He has lived and worked extensively abroad as a self-employed photographer and writer and his photographs are to be found in many publications. He writes regularly for the photographic press and is a fellow of the Royal Geographical Society, an associate of the British Institute of Professional Photography and a member of the Scientific Exploration Society.

1999 • 192pp • full colour throughout • 246 x 189mm • paperback
ISBN 0 240 515219 8

For more details visit www.focalpress.com

To order your copy call +44 (0)1865 888180 (UK) or +1 800 545 2522 (USA)
or visit the Focal Press website: www.focalpress.com

 Focal Press

www.focalpress.com
Join Focal Press on-line
As a member you will enjoy the following benefits:

- an email bulletin with **information on new books**

- a regular **Focal Press Newsletter**:
 - featuring a selection of new titles
 - keeps you informed of **special offers, discounts and freebies**
 - alerts you to **Focal Press news and events** such as author signings and seminars

- complete access to **free content** and reference material on the focalpress site, such as the focalXtra articles and commentary from our authors

- a **Sneak Preview** of selected titles (sample chapters) *before* they publish

- a chance to have your say on our **discussion boards** and **review books** for other Focal readers

Focal Club Members are invited to give us feedback on our products and services.
Email: worldmarketing@focalpress.com – we want to hear your views!

Membership is **FREE**. To join, visit our website and register. If you require any further information regarding the on-line club please contact:

> Lucy Lomas-Walker
> Email: l.lomas@elsevier.com
> Tel: +44 (0) 1865 314438
> Fax: +44 (0)1865 314572
> Address: Focal Press, Linacre House,
> Jordan Hill, Oxford, UK, OX2 8DP

Catalogue
For information on all Focal Press titles, our full catalogue is available online at www.focalpress.com and all titles can be purchased here via secure online ordering, or contact us for a free printed version:

USA
Email: christine.degon@bhusa.com
Tel: +1 781 904 2607 T

Europe and rest of world
Email: j.blackford@elsevier.com
el: +44 (0)1865 314220

Potential authors
If you have an idea for a book, please get in touch:

USA
editors@focalpress.com

Europe and rest of world
focal.press@repp.co.uk